Women Artists
of the West

FIVE PORTRAITS IN CREATIVITY AND COURAGE

c. 2

JULIE DANNEBERG

Women Artists
of the West

FIVE PORTRAITS IN CREATIVITY AND COURAGE

FULCRUM PUBLISHING
GOLDEN, COLORADO

To Alex

Text copyright © 2002 Julie Danneberg

Photographs used by permission.

Library of Congress Cataloging-in-Publication Data

Danneberg, Julie, 1958–
Women artists of the West : five portraits in creativity and courage /
Julie Danneberg.
p. cm.
Summary: Narrative profiles of five notable women artists who influenced
the art of the American West.
Includes bibliographical references and index.
ISBN 1-55591-861-1 (Paperback)
1. Women artists—West (U.S.)—Biography—Juvenile literature. 2.
Art, American—West (U.S.)—20th century—Juvenile literature. [1.
Artists. 2. Women—Biography. 3. Art, American—West (U.S.)] I. Title.
N6536 .D36 2002
709'.2'278—dc21

2002008400

Printed in Canada
0 9 8 7 6 5 4 3 2 1

Editorial: Marlene Blessing and Daniel Forrest-Bank
Design: Trina Stahl
Cover photograph, Dorothea Lange at work, 1936. Photograph courtesy of the Farm Security
Administration—Office of War Information Photograph Collection (Library of Congress).

Fulcrum Publishing
16100 Table Mountain Parkway, Suite 300
Golden, Colorado 80403
(800) 992-2908 • (303) 277-1623
www.fulcrum-books.com

Contents

Introduction

To FULLY UNDERSTAND THE WEST, or indeed anyplace, it is necessary to see it through more than one set of eyes, to know it through more than one set of experiences. Up to the beginning of the twentieth century most people's impressions of the American West came from male artists, many of whom lived primarily in the East and focused on the West's violence, harshness, and extreme lifestyle. While that is a valid picture, it is not the only picture. That is why the visual art of the women featured in *Women Artists of the West* is so important. Their paintings, photography, and pottery, created in the early to mid-1900s, present a new version of the West, bringing our picture into even clearer focus.

Through the simple, elegant pottery of Maria Martinez, we learn about the ancient, traditional Pueblo art of pottery making. Georgia O'Keeffe's paintings show the New Mexico landscape in vivid, lively colors. While Laura Gilpin's photographs capture the peacefulness of the West's wide open spaces, Dorothea Lange's photographs document the suffering caused by socio-economic events such as the Depression. Mary-Russell Colton not only captured the scenery of Arizona in her oil paintings, she helped create the Museum of Northern Arizona and thus, helped preserve the artistic traditions of the Hopi and the Navajo.

Each biography in this book serves as an introduction to the individual woman and her art, as well as the time, geography, and culture where that art was created. For each artist, the chapter's focus is on the time period leading up to their greatest work, the time when success was a dream and they were involved in the reality of trying to make that dream come true.

While you are reading *Women Artists of the West*, it is important to realize that this book is a work of creative nonfiction. Although the facts, places, dates, and events are accurate, the means used to communicate them is fictional narrative. The words you read from each individual are not exact quotes, but instead are the

author's creative rendering of what might have been said based on actual facts. A bibliography at the end of each chapter gives the sources of information.

The purpose of this book is to offer a deeper understanding of each woman by showing her life in relationship to the world around her. So, by switching between first and third person, the book offers the reader the unusual opportunity to see the West through the eyes and experiences of each of these artists, as well as gives the reader the benefit of observing each woman through the eyes of the West.

Women Artists
of the West

FIVE PORTRAITS IN CREATIVITY AND COURAGE

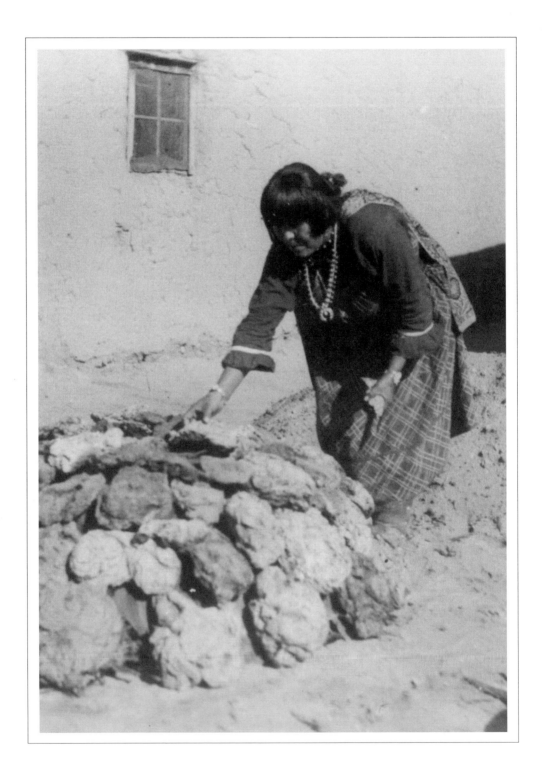

Maria Martinez

(1887[?]–1980)

〜✦〜

HAVE YOU EVER TRIED to make a clay pot? If so, was it evenly shaped? Did it have thin, smooth sides? Could you use your pot for cooking? Did it last for years without breaking?

Maria Martinez made pots that had all these qualities. Because she was an internationally known potter, examples of her work are shown in museums and treasured in private collections throughout the world. Not only that, Maria is credited with being the first Native American artist to sign her work. Why is this important? Because it shows that people valued her pottery as a unique piece of art created by a specific person. Maria's success paved the way for other Native American artists to receive recognition for their work, too.

Maria's pottery was not only made in the West; it was actually made *of* the West. The clay she used was western clay dug from the ground close to her home. She shaped the pots using ancient tools and techniques, and her husband, Julian, decorated them with designs modeled after those created by her ancestors.

At the time of her birth, no one guessed

An Almost Lost Art

When the Santa Fe Trail opened in 1821, white traders brought in all sorts of products new to the Indians, including metal pots, tin pans, and enamelware. Instead of continuing to make and decorate clay cookware and storage pots, the Indians began to trade for and use metal and tin products. The ancient tradition of Pueblo pottery was almost lost. Women like Maria's aunt Nicolasa kept the skill alive by passing their knowledge down to the next generation.

what an impact Maria's talent would have on her family, on her pueblo, and on the

OPPOSITE: *Maria getting ready to fire her pottery. Taken between 1925 and 1935. Photograph courtesy of the Denver Public Library Western History Collection.*

place of the Native American in the modern art world. In fact, there is no official record of the exact year of her birth, although the best guess is somewhere around 1887. Born in the isolated New Mexico pueblo of San Ildefonso, Maria was the third daughter in a family of five girls. Raised in the traditional lifestyle of her people, the Pueblo Indians, her mother taught her to grind corn, take care of a family, and cook traditional food. Maria learned how to make pottery by watching her Aunt Nicolasa make clay pots for cooking and storage. She attended the village school for several years and then continued her education for two more years at a boarding school twenty miles southeast in Santa Fe. Although she thought about becoming a teacher, mostly she wanted to get married, raise a family and live a traditional Pueblo life based on family, farming, and community.

MARIA: FALL 1903

That fall I helped Miss Grimes, the teacher at the pueblo school. I worked as a housekeeper in exchange for extra lessons. I'd already completed St. Catherine's Indian School in Santa Fe and thought I might want to be a teacher.

As the chilly autumn winds swept through the pueblo, I came early every morning to start a fire in the wood-burning stove. After a few cold days, the supply of firewood ran out and Miss Grimes hired someone to chop wood.

One day after class, as I worked at tidying up the schoolroom, I heard the door open and then slam shut. I turned around, expecting to see Miss Grimes, but instead came face-to-face with Julian Martinez, someone I'd known as a little girl in this very school. As a boy, Julian laughed and joked often and sometimes ran away from the teacher when he got in trouble. I saw right away that the laughing, joking boy I remembered from long ago had become a handsome young man.

JULIAN

I chopped firewood for Miss Grimes and then came inside and visited with Maria. We talked as she swept the floor and erased the board. Afterward, I walked her

home. Every day I came to chop wood because I wanted to see Maria. After a few days, the pile of cut wood rose almost to the ceiling. Mrs. Grimes told me that we had enough wood. I pretended I didn't understand her English words and came back the next day to chop more.

Maria laughed when she saw me. "You didn't have to come today," she said. "Don't you want me to come?" I asked.

Her blushing cheeks told me everything.

Reyes Montoya, Maria's Mother

Maria and Julian began spending lots of time with each other. People noticed them walking together, heads bent over whispering secrets or thrown back laughing. By this time, another young man wanted to marry Maria. He was a farmer and worked his own fields. But Maria spent all of her time with Julian, who made no such offers. I asked Maria if she wanted to marry the other young man but she said no.

Maria: Early 1904

I enjoyed being with Julian and I didn't care what people thought.

But one day, when Julian came to visit, I knew things had changed. He looked serious and said he wanted to talk. He explained that he had been hired to travel to the St. Louis World's Fair to work at an Indian exhibition put on for the tourists. Some of our friends from the pueblo were also hired to go. They would sing and do our traditional dances and work at our traditional crafts. Julian explained that many white people had never seen a real live Indian. They were curious about us and our culture. "I'll get paid fifty dollars a month just to be myself," he said with a laugh.

I heard the excitement in Julian's voice and saw the way his eyes sparkled when he talked about leaving San Ildefonso.

Julian asked me to marry him and travel with him to St. Louis. All of a sudden I felt shy. My heart fluttered and I kept my eyes turned down, looking at my white-knuckled hands folded tightly in my lap. Of course, I said yes.

Mother Knows Best?

Maria's mother and father, Reyes and Tomas Montoya, were concerned about her future with Julian. In a culture so dependent on farming, marrying a man with no land and no knowledge of farming was a risky proposition. Also, since Maria had no brothers, Tomas was hoping one of his sons-in-law would pitch in and help with the farming responsibilities.

JULIAN: SPRING 1904

After I knew that Maria wanted to marry me, too, I did everything the right way, the Pueblo way. My parents visited Maria's parents to ask about marriage. The next night, her parents visited mine to accept.

MARIA

My wedding lasted two days. On Sunday, all the people of San Ildefonso gathered for the marriage ceremony. The next morning, they gathered again as the priest married us in the village church. After that we feasted on roasted goat meat, tamales, frijoles, and stew. We danced and sang, laughed and told jokes. Everyone slapped Julian on the back and hugged me, wishing us both much happiness and good luck. The festivities lasted until midafternoon, when the wagon came to take us to the train in Santa Fe. What a day! I woke up Maria Montoya in San Ildefonso and went to bed Maria Martinez on a train heading for St. Louis, one of the biggest cities in the nation.

JULIAN: SUMMER 1904

We lived and worked at the fair, spending much of our time demonstrating Pueblo dances. Maria made Pueblo pottery for the white visitors.

MARIA: SUMMER 1904

I didn't like the way the tourists talked about me. "Look at her hair," a man said with a sneer. "Those Indian leathers look dirty," another woman said about my beautiful bridal moccasins. Sometimes they even called me names in English, assuming I didn't understand.

JULIAN

The funny part is that we understood what the tourists said about us, but they couldn't under-

WILL YOUR DAUGHTER MARRY MY SON?

Imagine asking your girlfriend to marry you while your parents are standing right there! In a way, that is what Julian did. Pueblo custom for an engagement required Julian to come with his parents on a formal visit to Maria's house to discuss the possibility of marriage.

To make the engagement official, Julian and his parents came for a second visit, this time bearing the traditional betrothal present, a string of multicolored beads called a rosario. Each mother made the rosario with the most beautiful beads she could find at the trading post. Julian's mother put a necklace around Maria's neck and Maria's mother put one around Julian's neck. The parents each said a blessing, and the couple was officially betrothed.

stand what we said about them because we spoke in Tewa, our native language. Many of the visitors were nice, though, and wanted to talk and ask us questions. Maria refused to speak, so I spoke for the both of us.

When we had time off, Maria and I explored St. Louis. San Ildefonso sits beside the Rio Grande River. St. Louis sits beside the Mississippi River. In places I can throw a rock to the other side of the Rio Grande, but the Mississippi is as wide as a lake. In our village, we can walk from end to end in a few minutes. St. Louis is the size of many, many of our villages put together. Our land is dry with mesquite and gray-green sage stretching out to meet the blue-purple hills. By the river the leaves on the cottonwood trees shimmer a silvery green in the afternoon light and the thunderclouds pile up thickly on the horizon. In St. Louis there are many trees, big and lush, their branches reaching toward the clouds. Colorful flowers fill the gardens locked inside black wrought-iron fences, and smooth grass covers the land like fields of corn.

MARIA

Making pottery, I felt less homesick. I forgot about the people watching me and thought of my family back home.

In the age-old traditional Pueblo way I had learned as a child, I started with a piece of clay, patting it into a flat bowl to form the bottom of the pot. I rolled snakelike coils, and one by one fitted them around the edge, slowly and carefully building up the walls to form the sides just like Aunt Nicolasa had shown me as a child. As I worked, I turned the growing pot

SWEET TREATS

The 1904 St. Louis World's Fair made long-lasting contributions to our American culture. Ice-cream cones were served for the first time, and the forerunner to the Popsicle was invented there. Called "fruit icicles," fruit juice was frozen in narrow tin tubes. As the juices melted, thirsty visitors sipped it from the tube.

A HUMAN EXHIBIT

Indians of the Southwest demonstrated their culture and art as one of many exhibits showing different world cultures at the St. Louis World's Fair. The most elaborate was the Philippine Exhibit. Set up along a lake shore, members of different aboriginal tribes from the East Indies were brought in. Each tribe constructed its own village. Some built huts on stilts over the water, while others built thatched huts on the hillside. During the fair, each tribe went about daily life while the visitors watched.

around and around, shaping it and smoothing it with a gourd scraper. I left the shaped pot out in the sun to dry.

SUBSISTENCE FARMERS

The men of San Ildefonso were "subsistence farmers." In other words, they didn't farm to make a profit but only grew enough food to feed their families. Occasionally, in a good year, a little bit of their harvest might be left over to be sold for cash or traded for work or goods. Although most people in the village were almost totally self-sufficient, there was also a small store on the reservation where Indians could buy food as well as hardware, material, and other dry goods.

FROM MOTHER TO DAUGHTER

In the pueblo, houses were not sold after the owner died. Instead, they were passed down to the daughter or another female family member. In this way, houses stayed in the family from generation to generation.

JULIAN: FALL 1904

Maria was pregnant when we returned home. I asked Maria's father, Tomas Montoya, to teach me how to be a farmer. I tried very hard to learn about the land and the weather and all the things that Tomas knew in his head and his heart.

MARIA: 1906

As a wedding gift, my parents had given me the adobe house that belonged to my grandmother. Julian and I lived there with our son, Adam. We were happy and the seasons flowed by as smoothly as river water.

JULIAN: SPRING 1907

The spring my daughter, Yellow Pond Lily, was born, Tomas and I labored and sweated over the land, pulling the plow, planting the seeds, and clearing the irrigation ditches. But as spring turned to summer, many long burning days of sun dried up our crops, and they blew away in the parched wind. This meant that we must buy our winter food. Many of our men left the village to get jobs. I too needed to find work in order to earn money to buy food for my family.

DR. EDGAR HEWETT: SUMMER 1907

In the summer of 1907 I led an expedition of scientists to New Mexico. We came to excavate prehistoric Pueblo sites found tucked into the mountains on the Pajarito Plateau, about thirty

miles from San Ildefonso. We came, eager to learn about the culture and day-to-day life of the ancient people who had lived there hundreds of years ago.

Archeological work is tedious: digging and digging down through layer after layer of dirt accumulated through the years. I hired some Indians from San Ildefonso to help us at the excavation site. They worked carefully, treating the place with respect. I was glad for their assistance.

JULIAN

Dr. Hewett hired me to help him dig up the villages of our ancestors. I planned to stay at the site all summer and begged Maria to come with me. She refused, saying she was afraid to live so close to white men.

The scientists drove a wagon filled with their supplies to the site. Without roads through the rough mountainous terrain the trip to the ruins proved long and difficult. When we got there, we set up a village of white canvas tents. Although I brought food of my own, the scientists had a cook and asked us to join them for meals. All of us, Indian and Anglo, cooked and ate together as a group. I enjoyed that.

During the day I worked within the crumbling walls of the cliff dwellings. We

THANKS!

Bandelier National Monument is found on New Mexico's Pajarito Plateau. By 1907, Hewett had already made several trips to this area with his friend, Adolph F. Bandelier. It was Bandelier who first saw the cliff dwellings there on October 23, 1880, describing them as "the grandest thing I ever saw." Hewett obviously agreed. Thanks in part to his archeological work there, these cliff dwellings and many more were set aside by the federal government for protection as a national monument.

A NEW FIELD

In the early 1900s, archeology was a new field and Dr. Hewett was one of its pioneers. The School of American Research was formed in 1907 to train students to do archeological research on the American continent and to preserve and study the cultures of the Southwest. Hewett was named director of the new school and brought his students to the Pajarito Plateau to learn about archeology firsthand. The information gained from these early trips contributed greatly to our understanding of some of the earliest cultures in the hemisphere.

Can You Dig It

The ruins on Pajarito Plateau had been buried, over the course of hundreds of years, under layers of dirt and debris. As Julian and other workers removed the dirt, each shovelful had to be sifted through screens in order to catch any stray pieces of pottery, tools, or other artifacts. Every artifact was a piece to the puzzle that, when finished, would help the scientists develop an understanding of ancient life on the plateau.

Burial

Pueblo tradition dictated that when a baby died it was buried inside the house, in the floor of the storeroom. This way the baby was always at home with the family. Marie didn't want to do that. Instead, they had a funeral and buried her in the cemetery.

When Julian died years later, again, according to Pueblo tradition, the body was taken away to a secret location to be buried. Even Maria didn't know where.

found old pots and tools, and even food and bones. Dr. Hewett called them "artifacts," saying each one was a clue to the past.

Maria: Summer 1907

The summer heat drove us inside. As the hot days crept along under the shimmering sun, a strange sickness traveled through the village, striking the weak, the old, and the young. One night Yellow Pond Lily awoke, her cheeks flushed with fever. She whimpered and cried in her crib. Her hands and feet felt hot and dry. I bathed her in cool water. I had her sip a tea of Romero weed and said many prayers, sending them upward in a cloud of cedar smoke. And still my little Yellow Pond Lily burned as hot as a red ember from the fire. Fear tangled up my thoughts, as I rocked her, cooing words of comfort. Despite my prayers, as the darkness lightened into a gray dawn, Yellow Pond Lily died.

I felt as empty as an old cracked pot. Mother helped me prepare her tiny body for burial.

Tomas

I made the long, slow walk up the canyon to tell Julian the bad news. Of course he wanted to come home to be with Maria. I said, "No, you still have your job to do.

Your grief and sorrow will not put food on the table this winter. Only your work can do that."

JULIAN: FALL 1907
I came home from Pajarito Plateau at the end of the summer. My heart sang when I hugged Maria close and threw a laughing Adam high into the air, but it sank when I looked for Yellow Pond Lily and remembered she wasn't there.

Dr. Hewett paid me one silver dollar for each day of work. I gave the money I earned to Maria. She divided it between our families, keeping some for us and giving some to our parents.

DR. HEWETT: SUMMER 1908
I returned that next summer to continue my work on the Pajarito Plateau. Julian eagerly joined our group again. One day I asked him to copy a painting of a water snake from the wall of a cave. When he showed me his drawing, I saw that he had a good eye and a sure hand. After that I kept him supplied with paper and colored pencils, asking him to copy many paintings and designs.

MARIA
This year, when Julian asked me to go with him, I said yes. I wrapped our clothes and cooking pots in blankets. As we traveled, Adam ran ahead, happy to be set free on an adventure. Julian and I smiled as he scrambled over rocks and hid on the shady side of a scraggly piñon pine. In the hottest part of the day, we ate our lunch and napped in the coolness under a wild plum tree.

Two other men brought their families, too. When we reached the ruins, the white men gave each family a tent and we set up a little village of our own under the ancient village of our ancestors.

The men went to work in the morning. The children played together and the women visited as we worked, grinding corn or shaping tortillas.

AN ARTIST IS BORN

After the first year at Pajarito Plateau, Julian was hooked. He kept a notebook to copy down designs he liked or wanted to remember. His collection of ideas came from ancient traditional designs he saw on pots and artifacts found at the archeological digs he worked on. Later he gathered more ideas from time spent at the Museum of New Mexico.

Unfortunately, Julian's notebook was burned along with all of his other possessions at the time of his death in 1943. This burning of personal belongings is part of the Pueblo burial tradition.

One day, Julian brought Dr. Hewett and another scientist, Dr. Kenneth Chapman, to our tent. Dr. Hewett showed me several round, smooth stones just a bit larger than robin eggs. "What are they and what were they used for?" he asked. I rolled them in my hand, explaining that they were stones used for polishing pottery. "This stone used to polish pots made from red clay," I said, pointing out the red color in the tiny cracks on the rock.

DR. HEWETT

I noticed how much Maria liked the old stones. I told her, "I must keep these stones and take them to the museum in Santa Fe. But, if you find some more in the ruins, you can keep them to polish your own pots."

MARIA

The next day, I left Adam with the neighbor and wandered over to some ruins not being worked on. I climbed up to an old cave in the cliffs. The smoke-darkened walls marked the place of ancient fires. Poking through the soft dirt near the back of the cave, I found four ancient polishing stones. Three were black, and one a shiny white. They fit perfectly in my hand. I tied them carefully into my handkerchief and brought them back to our tent.

DR. HEWETT: SUMMER 1908

Near the end of the summer, Dr. Chapman and I showed Maria an ancient potsherd from the ruins. "Can you make a pot like this?" I asked. Turning it this way and that in her hand, she looked it over. Her fingers felt its shape, her hands its curve. Maria explained that this pot was finer and more delicate than those she made. But she said she would

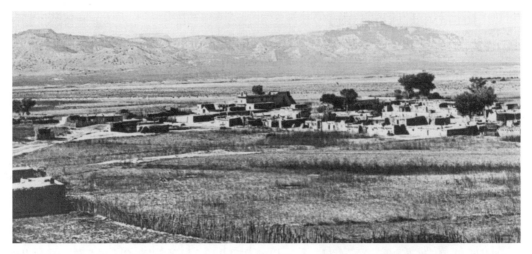

San Ildefonso Pueblo in 1911. Photograph courtesy of the Denver Public Library Western History Collection.

try to duplicate the shape and appearance of the pot. When I asked her if she could decorate the pot as well, she laughed. "I'm no good at drawing."

"Maybe Julian?" I suggested. Again Maria laughed. "Decorating pots is not a man's work." But I explained that this would give Maria and Julian a chance to work together over the winter. I also promised to buy any pots that she made.

MARIA: FALL 1908

When we got home, I worked at getting our family ready for winter. My father gave us food from his harvest, just as we gave him money from Julian's job. I dried beans, strung chiles, and ground corn into cornmeal. I cleaned our home from top to bottom, scrubbing the floors and walls with sand and rinsing all the sand off with water. Then I whitewashed the whole house until it looked and smelled new. Finally, I cut out and sewed myself two new dresses and made new clothes for Adam, too.

At last, with much excitement, Julian and I turned our attention to the ancient pottery shard Dr. Hewett gave us.

THANK YOU, MOTHER EARTH

The Pueblo Indians lived in close contact with the earth. Maria believed that the earth, the heavens, people, plants, and animals are all filled with hidden spirits and these spirits are to be respected and honored. She did this through prayers and special dances and ceremonies held throughout the year.

Julian: Early 1909

We tried to figure out what made this pot different from the ones Maria made and decided that the ancient clay must have been mixed with very finely ground sand. The sand strengthened the clay, making the walls of the pot thin but resistant to breakage. Maria's Aunt Nicolasa told us where to look for this fine sand to mix with our clay.

Maria: Winter 1908–1909

Julian and I took the wagon, enjoying the watered down warmth of the winter sun. We bounced along until we found the special sand on a beach in a lazy curve of the river. After we loaded it into old cloth flour bags, we ate our picnic. Adam splashed us until Julian chased him into the water.

On the next warm day we traveled to a hillside to dig out the clay. When we found the spot, we sprinkled corn flour on the ground and said a prayer of thanks. Then, we spread an old blanket on the ground and piled clumps of hard, dry clay on it as we pulled it from the hillside.

It took many days of patient work to make that clay as soft and pliable as tortilla dough. First I picked out rocks and sticks and then I put it through a sifter. When it was clean and smooth, I mixed in the sand and, adding water, kneaded it like bread dough. My arms and hands ached from the kneading, my back cramped from leaning over my work.

Guaco

Guaco, the black paint used to decorate the pots, was made from the Rocky Mountain Bee Plant. When describing the process of making guaco in the book Maria by Richard Spivey, Maria said: "That guaco—have to boil it, oh like syrup. We have to cook, cook, cook long time. . . . And then we sift it, sift it in a screen and then take it outside and put it in a flat bowl and it dries like candy. And after it dries, then we take it and break it and store it. Every time we want to use it we get a piece and then soak it in water."

Julian

While Maria prepared the clay, I prepared my materials also. Just as my ancestors did before me, I walked out among the sage and cactus, I cut some spiny leaves from the yucca plant. After stripping away its stringy outer layer, I chewed on the ends until they formed a tip like a paintbrush.

To make the black paint or guaco, I looked for the wild bee plant, a form of spinach. I cut some leaves and brought them to the house. Maria boiled them and

boiled them again until the leaves turned into a thick, black syrup. To make the white paint, I mixed white clay with water, and for the red color, I mixed red clay with water.

MARIA

To make my pottery I sat outside on the shady side of the pueblo. As I rolled the clay between my hands, I listened to the sounds of the village: children calling to each other, dogs barking, the church bell ringing. The smell of baking bread wafted through the air. My neighbors bustled here and there, hauling water from the well or working in their gardens.

JULIAN

When the pots were dry, Maria painted on a slip, a mixture of clay and water. Using smooth polishing stones, she rubbed it quickly before it dried. This is what makes the pots shiny after they are fired.

Julian Martinez in front of Ancient Pueblo ruins on Pajarito Plateau, 1910. Photograph courtesy of the Denver Public Library Western History Collection.

My stomach lurched when it came time to decorate, because I didn't want to make a mistake. I planned the design in my head using patterns and pictures taken

YOU CALL THAT AN OVEN?

The women of San Ildefonso baked their bread in outdoor ovens called hornos. These igloo-shaped ovens were made of adobe, about four feet around and four feet tall. Many scientists believe that the Spaniards introduced hornos to the Indians. Ovens exactly like the ones in New Mexico were also used in Spain and France hundreds of years ago. A fire is built inside the horno; once it burns down, food is put inside and left to cook slowly.

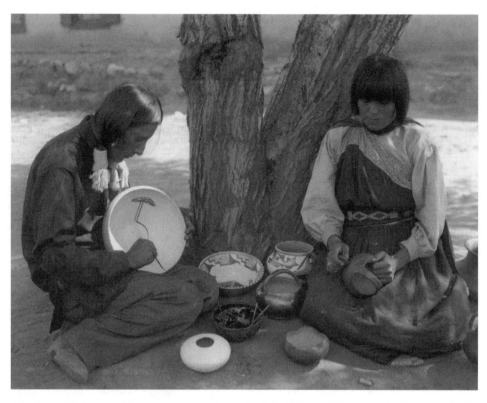

Maria and Julian working on pottery on the patio of the Palace of Governors in Santa Fe, 1912. Photograph courtesy of the Denver Public Library Western History Collection.

from ancient pots. Sometimes I painted the water serpent circling the pot, its tongue a lightning bolt. Sometimes I painted white feathers against a dark background. I painted triangles filled in with straight thin lines and a stair-step pattern climbing up and down around the base. Each pot was different and so were my designs.

After all that work, it was time to fire our pots. We waited for a perfect day, a day with no wind. We built a fire, stacking the pots and covering them with wood and dried dung. Maria sprinkled the pile with corn meal and said a prayer, and then I lit the fire. When the fire cooled down, we held our breath as we pulled out our shiny pots.

MARIA: SUMMER 1909
We made five bowls for Dr. Hewett that winter. Three came out of the fire with Julian's designs sharp and clear. But two had turned a solid black during the firing.

We proudly showed the good bowls to Dr. Hewett when he returned to San Ildefonso.

DR. HEWETT: SUMMER 1909

The pots Maria showed me took my breath away. They were strong, useful, simple, symmetrical, balanced, and beautiful. They were made using knowledge and skills passed down through the ages, a bridge to a culture long gone as well as a means of salvation for the Pueblo people. I understood even before Maria and Julian that people—many people—would want to buy their handiwork.

❧ *Afterword* ❧

IN THE SUMMER of 1909, Julian traveled once again with Dr. Hewett to Pajarito Plateau. Maria stayed behind and made pots—two hundred of them. The pottery-making tradition that would make Maria famous had begun.

In the meantime, as Maria and Julian were growing a business, they were also growing a family. Maria's second son, Juan, was born in the summer of 1909. Her mother, Reyes, was pregnant at the same time as Maria. Reyes died as a result of childbirth, and Maria took on the responsibility of raising her young sister, Clara. More than ten years later, Maria had two more sons, Tony and Felipe.

In the fall of 1909, Dr. Hewett asked Julian to come to Santa Fe and work as the caretaker at the newly created Museum of New Mexico. Eventually, Maria and their sons joined him there. On nice days tourists often found Maria making pots and Julian decorating them outside the museum. Tourists could then buy them in the museum store. Julian and Maria made a good living and their pottery was recognized and requested by the tourists who visited Santa Fe.

After three years, Maria and Julian moved back to San Ildefonso, where they sold their pottery from their home. By accident, Julian learned to fire pots a new way, a way that created the beautiful shiny black finish known as black-on-black pottery. He saw that smothering the burning fire with manure caused the pots to turn black. Eventually Maria and Julian became known for their black pottery.

As Maria earned more money, friends and family from San Ildefonso asked for help getting started in the same business. Maria and Julian generously shared all they knew about pottery, including the popular new technique for creating black-on-black pots.

When Julian died in 1943, Maria continued making pottery, partnering first with her daughter-in-law and then with her third son, Tony.

Maria's success not only helped revive the failing economics of her own tiny village in New Mexico; it also paved the way for other Native American artists to receive recognition. Although famous, Maria never lost sight of her priorities: to be a good wife, mother, and member of her community. Once, when asked about her fame, she responded that she was a Pueblo woman, nothing less and nothing more.

⤳ *Bibliography* ⤳

Anderson, Peter. *Maria Martinez: Pueblo Potter.* Chicago: Children's Press, 1992.

Hyde, Hazel. *Maria Making Pottery.* Santa Fe: Sunstone Press, 1973.

Keegan, Marcia. *Pueblo Girls: Growing Up in Two Worlds.* Santa Fe: Clear Light Publishers, 1999.

———. *Pueblo People: Ancient Traditions Modern Lives.* Santa Fe: Clear Light Publishers, 1999.

Kreisher, Elsie Karr. *Maria Montoya Martinez: Master Potter.* Gretna, La.: Pelican Publishing, 1995.

Marriott, Alice. *Maria: The Potter of San Ildefonso.* Reprint. Norman: University of Oklahoma Press, 1989.

Noble, David Grant. *Ancient Ruins of the Southwest: An Archeological Guide.* Flagstaff, Ariz.: Northland Publishing, 2000.

Peterson, Susan. *The Living Tradition of Maria Martinez.* New York: Kodansha International, 1978.

Spivey, Richard. *Maria.* Flagstaff, Ariz.: Northland Publishing, 1979.

Swentzell, Rina. *Children of Clay: A Family of Potters.* Minneapolis: Lerner Publishing, 1992.

Underhill, Ruth. *Life in the Pueblos.* Santa Fe: Ancient City Press, 1991.

Georgia O'Keeffe

(1887–1986)

〜〜〜

TODAY, GEORGIA O'KEEFFE is recognized as one of the finest painters America has produced. But what earned her this title? And why is so much of her art tied to the West?

Georgia O'Keeffe's art was different from anything that came before it. Famous for her close-up views of flowers, bright colors, and simplified landscapes, many of her paintings are considered abstract art. That is because they were not exact copies of what she saw but instead her interpretation in which she used strong shapes, simple forms, and vivid colors. Georgia explained her more abstract art in this way: "A hill or a tree cannot make a good painting just because it is a hill or a tree. It is lines and colors put together so that they say something." Georgia's paintings always said something about her emotions. She didn't just paint what she saw, but instead she painted what she felt when she saw it.

During her first extended visit to New Mexico in 1929, Georgia wrote a letter to her sister, Catherine. "I am West again, and it is as fine as I remembered it—maybe finer—There is nothing to say about it except the fact that for me it is the only place." The western landscape with its rugged mountains, primitive land-forms, and wide-open sky called forth strong feelings in Georgia. She experienced new sights and sounds, tasted different foods, and felt deeply moved by the ancient culture she saw all around her. This newness energized her and was reflected in her paintings. She painted purple sunsets over pink-tinged mountains, a black lake with silver sunlight glinting off its edge, the restful curves and cool adobe walls of the church in the Taos Pueblo.

Georgia's love of nature probably started in her childhood. She grew up on a farm in Sun Prairie, Wisconsin, with four sisters and two brothers. From a young age her parents recognized and nurtured her natural artistic talent. When the family could afford it, she attended art school. When they couldn't, Georgia

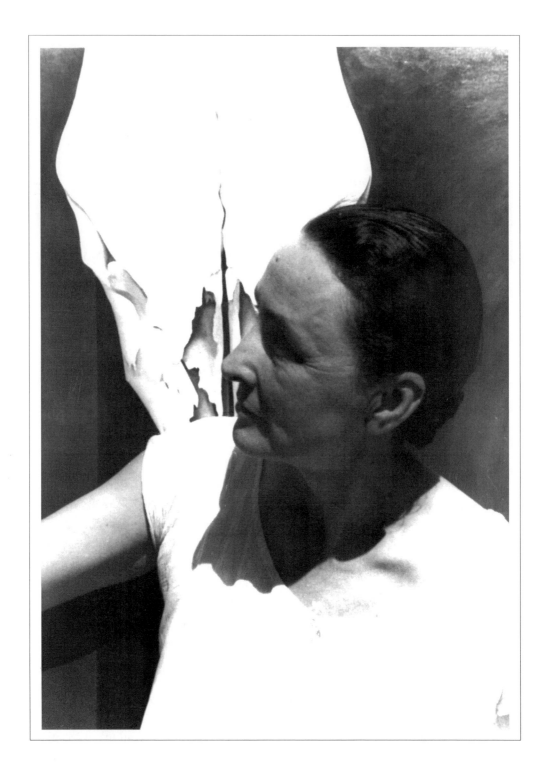

worked as an art teacher. Through it all, she held fast to her dream of becoming a successful artist.

Early in her career Georgia decided to stay true to her own style no matter what. She learned to listen to her instincts and emotions and then expressed them with paint. Often, especially at the beginning, friends and colleagues didn't understand her unusual style. However, in 1916, Alfred Stieglitz, a famous and influential New York photographer and gallery owner, saw some of her abstract charcoal sketches. He liked them so much he set up a showing in his gallery and right from the start, Georgia's art was noticed.

Stieglitz continued to champion Georgia's work. As time passed, their relationship grew beyond business. They were married in 1924.

MABEL DODGE LUHAN: WINTER 1928

"Darlings, you really *must* come and visit me in New Mexico," I urged my friends, Alfred Stieglitz and Georgia O'Keeffe, as we talked over tea and toast in the cafeteria of their hotel. I thought Georgia looked tired and worn out, and thinking she needed a change of pace, I told her all about the absolute healing power of a trip to Taos. "It is positively magic there, my dear," I said. I explained how artists and writers came from all over the world seeking inspiration. Some of the most famous I welcomed into my home. I so wanted Georgia and Stieglitz to come too. I just knew they would love it.

"No, thank you," Stieglitz said right away. Huffing and puffing like an indignant old bull, he rambled on about his summers at the lake and how he couldn't *possibly* consider traveling halfway across America. I could tell that he assumed Georgia felt exactly the same way.

ALFRED STIEGLITZ

Before Alfred Stieglitz and Georgia O'Keeffe were marriage partners, they were business partners. When they first met, Georgia was an unknown artist and Stieglitz was well-known for his pioneer work in photography. He also owned a small but well-known art gallery, 291, in New York City, where he showcased avant-garde art. Stieglitz had a good eye for talent. He gave the American public its first view of the modern French painters Cézanne and Toulouse-Lautrec, and Picasso had his first introduction to the United States at 291.

OPPOSITE: *Georgia O'Keeffe posing with bones from New Mexico, 1936. Library of Congress, Prints; Photographs Division, Carl van Vechten Collection [reproduction number, e.g., LC-USZ62-54231].*

The Not-So-Shabby Shelton

For ten years O'Keeffe and Stieglitz lived at the Shelton in New York, a residential hotel. Georgia especially liked this arrangement because it freed her up from housekeeping chores. Living on the thirtieth floor, Georgia ate in the cafeteria, exercised in the lap pool, and enjoyed a short commute to Stieglitz's gallery. The outstanding view from their suite inspired many of her famous cityscapes. In a letter to a friend, Stieglitz described high-rise living: "The wind howls and shakes the huge steel frame—We feel as if we are out in mid-ocean—All is so quiet except the wind—and the trembling shaking hull of steel in which we live."

But Georgia didn't. She got a faraway look in her eyes and told me about her love of the West, calling it her spiritual home. She is *so* dramatic, you know. Nevertheless, when I left them that morning, I had a hunch I'd be seeing Georgia in New Mexico sometime soon.

Alfred Stieglitz: New York, Spring 1929

The Price of Success

Georgia sold her first picture in 1918. A charcoal sketch, it sold for less than $100. By 1927 it wasn't unusual for her to receive $3,500 for a painting. Another sign of growing recognition was Georgia's invitation in 1929 to show five of her paintings in an exhibition at the Museum of Modern Art in New York City.

O'Keeffe left me behind—left me at Lake George all by myself. My heart ached with loneliness as I tottered around the empty house without her. I worried about her constantly and wondered if she missed me as much as I missed her.

I shouldn't have allowed her to go. Well, come to think of it, I did say no. But did she listen? Of course not! Then she got her doctor to talk to me. "For her health," the doctor said. "A change of scenery will do her good." What could I say to that? Of course I wanted Georgia happy and healthy. I just didn't particularly want her happy and healthy away from me!

Georgia: Spring 1929

Stieglitz thinks that I'm weak and fragile and need to be taken care of. Ha! Fragile I'm not. As for weak, not very.

The doctor was right, though. I did need a change of scenery. I couldn't bear the thought of returning to Lake George for yet another summer. I felt so trapped there—the thick trees dripping with greenery, the humid air so heavy and damp. And worse still, people coming and going constantly. I dreaded spending day after day with the same old people having the same old conversations about the same old topics.

I'm an artist whose inspiration comes from the world around me. I hadn't painted for months because I was tired of living the same old life and seeing the same old things. I needed to be away from Lake George and its distractions. I needed to be away from New York City and its tall buildings and tiny square patches of sky.

I brought my friend, Beck Strand, along with me. She promised Stieglitz she would keep an eye on me and would make sure I took care of myself. Honestly, sometimes Stieglitz acts more like an old mother hen than a husband!

Rebecca "Beck" Strand: May 1929

Georgia and I, giddy with excitement, left New York on April 27. The trip to New Mexico took three days and nights by train. I promised Stieglitz I'd write to him all about our trip. He really wanted to know all about Georgia. He acted like our travels took us to the deepest, darkest part of Africa instead of just across the country.

Georgia boarded the train, her face gray and pinched, overcome with guilt about leaving Stieglitz. But as we left the East behind, the tension faded from her

Creative Genius

Each artist approaches the task of creating art in an individual way. According to biographer Laurie Lisle in Portrait of an Artist: A Biography of Georgia O'Keeffe, *Georgia's creative process involved locating an intense feeling about something, exploring it, and then trying to grasp it more completely by transmitting it to canvas. Georgia said, "I know I cannot paint a flower. I cannot paint the sun on the desert on a bright summer morning, but maybe in terms of paint color I can convey to you my experience of the flower or the experience that makes the flower of significance to me at that particular time."*

eyes and they began to sparkle as wave after wave of spring-green prairie flew by our window. The sky looked bigger and bluer, and the horizon hovered in the distance, a jagged blue line to the west. She smiled as the snow-covered mountains sliced through white clouds. Finally, as we crossed the border into New Mexico, Georgia laughed.

It's a Small World

Photographer Dorothea Lange, her husband artist, Maynard Dixon, and their two children lived in Taos in 1931. At that time Dorothea saw a photographer walking out to his work each morning and returning each night. She was envious that his life allowed him the freedom to pursue his art so totally. The man she saw in Taos was Paul Strand, friend of Georgia, student of Alfred Stieglitz, mentor and inspiration for Ansel Adams, and husband of Beck Strand.

Georgia: On the Way to Santa Fe, 1929

I loved the train trip. So relaxing. The rhythmic rocking and the musical clattering of the wheels against the metal tracks soothed my jangled nerves. Leaning my head against the cool glass window, I thought back almost twenty years to a time before Stieglitz, before fame, and before my hectic, big-city life. As a nineteen-year-old art teacher, I arrived in Amarillo, Texas, with a small suitcase and big expectations. Right from the start, I loved everything about the West—the sky stretched out forever above rolling prairies crisscrossed with jagged canyons. Every day after school, I walked away from the town and painted and painted and painted. I felt something different there, something I didn't feel back home. I suppose it was because the land wasn't boxed up into skyscrapers or hidden under concrete streets and sidewalks. It wasn't contained or tamed by a city, but wild and wonderful right before my eyes. When I left Amarillo, I swore I'd come west again. So, as the train rattled its way to Santa Fe, it seemed to be singing over and over, "You're going home, you're going home."

Beck: Santa Fe, Summer 1929

In Santa Fe we walked through the dusty streets to our hotel, La Posada, where we paid $2.50 a night for a nice room with running water. That evening we strolled through the plaza in front of the Palace of the Governors, the oldest building in Santa Fe. Georgia and I sat on a bench while people bustled around us. Indians displayed their work on colorful woven rugs. Talkative tourists oohed and aahed over handmade silver jewelry and intricately decorated clay pots. Spanish

storeowners swept their front steps, or rearranged their window displays. "We're here," Georgia said with a contented smile. "I can't wait to start painting!"

GEORGIA: SUMMER 1929

As we walked through the streets of Santa Fe the next morning, I felt the last of New England's claustrophobia fall from my shoulders. I turned my eyes toward the huge expanse of the New Mexico sky.

BECK: SUMMER 1929

No time to waste. Right away we signed up for a Fred Harvey tour. Our guide, a pretty young girl, chattered endlessly about the history of the area, pointing out sights along the way. We drove south to San Felipe Pueblo, where we found a place to sit on a flat-topped adobe roof, our feet dangling over the edge. In the plaza below, the Pueblo Indians performed the Corn Dance.

GEORGIA: SUMMER 1929

I will always remember seeing that first Pueblo dance at San Felipe. The painted, costumed Indians moved slowly in an ancient formation to the beat of a drum. Chanting in their native language, they summoned the rain to water their crops. I felt that deep, insistent drumming rumble up through my feet. Slowly, the pulse of my heart began to match the pulse of the drum.

BECK: SUMMER 1929

We ran into Mabel Dodge Luhan and her husband, Tony, at the dance. What a funny couple! How on earth did tall, handsome, dignified,

VISITING SAN FELIPE

D. H. Lawrence, a famous English author, had a ranch in Taos. He described a dance he saw at another pueblo in this way: "Never shall I forget the utter absorption of the dance, so quiet, so steady, timelessly, rhythmic and silent, with ceaseless down-tread, always to the earth's center. . . . Never shall I forget the deep singing of the men at the drum, swelling and sinking, the deepest sound I have heard all my life."

FAMOUS FRIENDS

Mabel Dodge Luhan, a wealthy heiress from Buffalo, New York, housed, fed, and entertained many artists, writers, and thinkers of the day. Willa Cather the writer, Laura Gilpin the photographer, and of course D. H. Lawrence were among the famous talented visitors. In fact, Mabel gave D. H. Lawrence the New Mexico ranch, Kiowa, in exchange for the manuscript of one of his most famous books, Sons and Lovers.

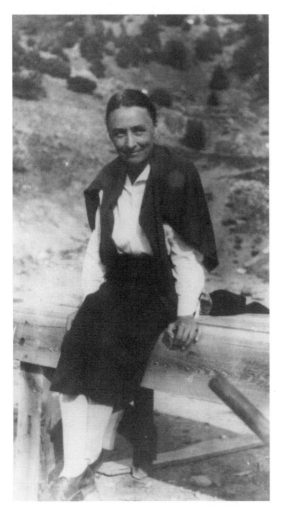

Georgia O'Keeffe near the guest house belonging to Mabel Dodge Luhan in Taos, New Mexico, 1929. Photograph courtesy of the Museum of New Mexico (negative 9763).

silent Tony, a Pueblo Indian, get matched up with squatty, nosy, talkative Mabel? The minute she saw us, Mabel fluttered toward us, chitchatting about all the things we needed to do and see in New Mexico. Of course, she absolutely insisted that we come to her house in Taos right away. Although we had planned to stay in Santa Fe for a few days, we packed our bags because Mabel wouldn't accept no for an answer. To tell the truth, I wasn't surprised by her invitation. She collects interesting and sophisticated friends like some people collect coins. Obviously she wanted to add Georgia to her collection.

MABEL: SUMMER 1929

Thrilled to death! That's how I felt to have those two women staying at my house. "Stay all summer," I said, settling them into their guest quarters. I also gave Georgia the use of a studio for her painting. Although her art didn't grab me, it certainly was all the rage in New York.

GEORGIA: SUMMER 1929

"It's perfect," I gasped when Mabel first opened the door to the studio, a round adobe building shaded by a cluster of towering cottonwood trees. Later, as I painted, the rustle of the leaves and the gurgling of a nearby stream serenaded me. From the windows I looked out over a sun-dappled meadow toward hazy blue mountains.

When I received letters from friends in New York, they seemed puzzled. "What do you do all day out in the middle of nowhere?" they asked, assuming that a tiny village like Taos, without plays or libraries or museums or fancy restaurants,

had nothing to offer. But the truth is, I filled my days soaking in the awesome vastness of the sky and the harsh beauty of the sunbaked hills. I lived each day with my eyes wide open because each day brought me something new to see and do and feel.

When I first got to New Mexico, I wanted to paint. I tried, but I couldn't. The sights and sounds were strange to me and I didn't know how to capture them. But I waited patiently, knowing that eventually a time would come when I would pick up my brush and all that I was taking in would spill out onto the canvas.

BECK: SUMMER 1929

I reported to Stieglitz that, with each passing day, Georgia appeared happier and stronger. We both did. The sun worked like medicine as we sunbathed in our birthday suits, giggling like schoolgirls at our boldness while the orange-red heat soaked into our bones.

Every day we explored, going farther and farther away from town.

But New Mexico is big—very big. There was so much to see and the day wasn't long enough to see it all. It didn't take long before Georgia just up and decided she wanted to learn to drive. Tony and I tried to teach her, but let me tell you, it wasn't easy!

GEORGIA: SUMMER 1929

You might think it strange that I, a grown woman of forty-two, did not know how to drive a car. But after a couple of days I figured, Why not? What better way to taste this new freedom?

BECK: SUMMER 1929

"Watch out!" I yelled as we narrowly missed a tree or drove within inches of a boulder. "Brakes! Shift! Stop!" Laugh, scream, hold on for dear life, and laugh some more. That about describes Georgia's driving lessons.

True to form, after only a few days behind the wheel, Georgia decided she didn't just want to drive someone else's car, she wanted one of her own. I knew Stieglitz would not approve, but once Georgia makes up her mind, she is like a steam engine plowing ahead until she gets where she wants to go. We soon found and bought a car, a black Ford Sedan with steel-blue interior. It cost $678. Georgia named the car "Hello!"

STIEGLITZ: LAKE GEORGE, SUMMER 1929

"What?" I exclaimed when I first heard of this new treachery. "A car? She'll kill herself," I said to whomever would listen. I pictured her careening over deserted dirt roads and meandering around in the middle of nowhere.

GEORGIA: 1929

Thanks to "Hello!" I had a few adventures on my own. When the small talk and curious houseguests got to me, I packed up my painting equipment and some camping gear and took off. What a luxury! I drove until something caught my eye: a certain landscape, the smooth roundness of a treeless hill, a color, a shadow. Parking in the shade of a twisted pine tree or beneath the overhang of a yellow sandy cliff, I often painted until daylight faded into darkness. After plopping my sleeping bag on the bare ground, I'd gaze up at a ceiling of stars and listen to the night sounds of animals rustling in the brush, a far-off coyote's howl, and the whoosh of the wind.

DEMON DRIVER

In her book, Portrait of an Artist, *Laurie Lisle quotes a letter Mabel Dodge Luhan wrote describing Georgia's driving: "Finally we recognized that Georgia was destined to become a demon driver! Some unaccountable guardianship protected her when, catching site of a peerless vista stretching below to the deep abyss, she reached her long arm pointing downward and exclaimed in ecstasy: 'Look at that!' made straightway for it, forgetting, with an unaccustomed experience of mechanics, that the wheels follow the hand unless one does something about it. . . . She would return after a couple of hours of frenzied velocity feeling ten years younger."*

STIEGLITZ: LAKE GEORGE, SUMMER 1929

Driving? Camping alone in the desert? Horseback riding? I begged O'Keeffe to come home. "For the sake of your health," I said. The more she resisted, the more I begged. I missed her terribly. I wrote to her every day, sometimes more than once.

Finally, O'Keeffe gave in and agreed to return home early, but I said she could stay.

GUEST: SUMMER 1929

I liked Georgia O'Keeffe. She wasn't a prim and proper city gal or a fancy artist too good to talk to the rest of us. Georgia seemed so full of life, always laughing and planning the next adventure with her friend, Beck. I took a walk with her one cool morning after breakfast. I declare, I never did see anyone get so excited about nature. Blue larkspur lined the walk, proud blue spears of color. Georgia dropped down to look at a single flower real close. She pulled me down to look at that flower up close, too. I'd never done that before. I'd always looked at nature from a distance. You didn't do that with Georgia. She wouldn't let you. I liked being with her because I saw the world through new eyes.

THE LAWRENCE TREE

Lie on the ground looking up into the branches of a tall tree and you'll understand the inspiration behind Georgia's 30 x 40 oil painting titled, "The Lawrence Tree." The brown trunk of the tree stretches upward, thick and strong from the bottom right corner of the canvas. The branches, wavy tentacles, hold up the night-blackened leaves. A dark blue starry night sky frames the foliage.

GEORGIA: SUMMER 1929

Tony took me camping in the mountains above Taos. We rode our horses higher and higher up the pine-covered slopes. The air felt cool against my skin, although the sun still shone with summer brightness. We rode through rocky meadows alight with the colors of wildflowers: red Indian paintbrush, purple daisies, and tiny bluebells. We quenched our thirst by scooping up icy water from a stream, and we made snowballs from banks of unmelted snow tucked in the deep shaded pockets of the high forests. In the late afternoon, we rode above the trees where the steepness flattened out into a bald, round peak. The sky darkened suddenly, and we sat with our packs flattened against a towering rock while thunder echoed off the rocks and lightning hissed and flashed. I thought I felt electricity sizzle through the air, but then again, it may have been the energy I felt being alive and seeing the power of nature up close.

BECK: SUMMER 1929

Tony took us to Taos Pueblo when he went to visit his friends. Georgia and I set up our easels in the shade of a cottonwood and painted the soft, brown adobe village, each lost in our own thoughts and imagination.

Taos Pueblo Indians and tourists gather on plaza of Taos, New Mexico. Photograph courtesy of the Denver Public Library Western History Collection.

GEORGIA: SUMMER 1929

I especially loved the sunsets. Just beautiful. Often, in the late afternoon I trotted off by myself away from town toward the eastern hills. Rolling along in my saddle as the horse kicked up dust and picked its way through the cactus, I breathed in deep the spicy scent of mesquite and sage. Sometimes I sketched, but often I just sat and observed, watching the world change colors as the sun set. The brown hills turned to crimson and the valleys filled with cool purple shadows. As I headed toward home, I took in the quiet, wave after wave of silence. I took big gulps of that silence, drinking it in so I would have something to take back to the noise of the city.

At the end of August, after a car trip to the Grand Canyon in Arizona, the time came when

SIGNATURE STYLE

Unlike most artists, Georgia O'Keeffe did not sign her paintings. Occasionally she did write her initials on the back of a canvas, but generally she felt her style and subject matter identified her clearly enough.

I felt full to overflowing. I was ready to go home. I packed my bags, but as the train chugged out of the station I knew that I would return.

❧ Afterword ❧

AFTER THAT FIRST visit to New Mexico, there was only one time when Georgia didn't return for at least part of the year. Her visits became a necessary part of her creative life. For several years she stayed at different places, each more isolated than the last. Finally, Georgia bought her own house in New Mexico, in the tiny town of Abiquiu. Originally a Pueblo Indian village, it was now a tiny community of mostly Spanish and Indians. When Stieglitz died in 1946, Georgia moved to New Mexico to stay.

Her vision of the Southwest, with its adobe churches, desert sunsets, and blue sky seen through bleached white cattle bones, was the first glimpse many

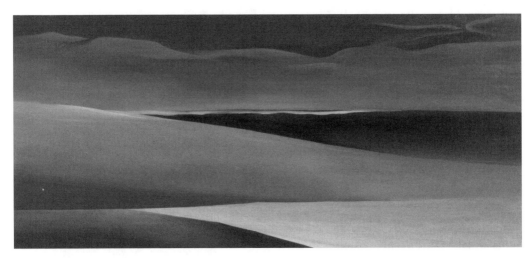

Untitled (Bear Lake), 1931, by Georgia o'Keeffe. Courtesy of the Museum of Fine Arts, Museum of New Mexico.

Americans had into the culture, wild beauty, and mystery of the Southwest. When people called her the best woman painter in America, her response was typical Georgia O'Keeffe: "The men like to put me down as the best woman painter. I think I'm one of the best painters."

Georgia continued to paint until the end of her life, at the age of ninety-eight. She never took the easy path or rested on past successes. Until the very end of her life, Georgia pushed the envelope with her art, experimenting with new ideas and exploring new landscapes.

≈ *Bibliography* ≈

Ball, Jacqueline A., and Catherine Conant. *Georgia O'Keeffe: Painter of the Desert.* Woodbridge, Conn.: Blackbirch Press, 1992.

Berry, Michael. *Georgia O'Keeffe.* New York: Chelsea House, 1988.

Brooks, Philip. *Georgia O'Keeffe: An Adventurous Spirit.* New York: Franklin Watts, 1995.

Castro, Jan Garden. *The Art and Life of Georgia O'Keeffe.* New York: Crown Publishers, 1985.

Gherman, Beverly. *Georgia O'Keeffe.* New York: Atheneum, 1986.

Hogree, Jeffrey. *O'Keeffe: The Life of an American Legend.* New York: Bantam Books, 1992.

Kent, Deborah. *New Mexico.* New York: Children's Press, 1999.

Lisle, Laurie. *Portrait of an Artist: A Biography of Georgia O'Keeffe.* Albuquerque: University of New Mexico Press, 1986.

O'Keeffe, Georgia. *Georgia O'Keeffe.* New York: Viking Press, 1976.

Pollitzer, Anita. *A Woman on Paper: Georgia O'Keeffe.* New York: Simon and Schuster, 1988.

Robinson, Roxana. *Georgia O'Keeffe: A Life.* New York: Harper and Row, 1989.

Laura Gilpin

(1891–1979)

W HERE DID YOU grow up? Do you think the sights and sounds of your childhood affected the way you think and feel and even the way you see the world around you?

Laura Gilpin was a native-born westerner. The sights and sounds of her childhood included seeing the full winter moon set behind the snow-covered summit of Pikes Peak, dangling her feet in ice cold rivers, and hearing the rush of wind through a prairie full of buffalo grass. As Laura grew, the rugged beauty of her surroundings became a part of her. When talking about her life in the West, she once said, "It's where I belong."

From a young age, Laura found her voice in the medium of photography. Her camera was a constant companion, and through its lens she studied the world.

As an adult she preferred to focus her lens on the western landscape. Laura was the only female landscape photographer of her time. Up until then it was considered a man's job, requiring physical strength, independence, self-reliance, and the ability to be away from family and friends for long stretches of time. Stubborn, independent Laura fit the bill.

Along with her landscape photography, she became known for sharp focus portraits of Navajo women and children. The Navajo allowed Laura to photograph a life previously unknown to outsiders.

While other artists traveled from their homeland to photograph the scenery and vistas of the West, Laura was already home. Her photographs showed a loving relationship with a land she knew well.

OPPOSITE: *When no one else will pose for you, there's always a self-portrait. Laura took this one in 1912. Photograph courtesy of the Amon Carter Museum (1912, autochrome, no. P1976.146.37).*

Geneneral Palmer, founder of the city of Colorado Springs, first discovered the site when scouting a route to California for the Kansas Pacific Railway in 1869. Swept away by the beauty of the valley with Pikes Peak towering to the west and the plains stretching out to the east, Palmer vowed to return. He did in 1871, as president of the Denver and Rio Grande Railroad, a rail line intended to run south from Denver to Colorado Springs and beyond. Palmer, envisioning "the most attractive place for homes in the West," bought up thousands of acres of land and started his city.

Gen. William Jackson Palmer: Colorado Springs, 1900

I was famous in Colorado Springs. Rich, too. But nine-year-old Laura didn't care about my fame or my money. That's one of the reasons why I looked forward to her visits. I admired Laura's character. She always saw the best in people and situations. No prim and proper parlor girl, she looked pretty as a picture with her huge brown eyes and long brown hair pulled back in a big bow. Laura liked the outdoors and so did I. We hiked or went horseback riding together. But no matter what we did, we always found plenty to talk about. And let me tell you, that little girl could talk. But she could listen, too. Liked to listen, in fact. I chuckle when I think of the way she'd ask me questions just to get me talking.

Laura: 1900

I spent some happy times in the company of General Palmer. What a kind man! Going to his house on the edge of town was always fun, and even back then, as a nine year old, I kept my eyes open for adventure. The Palmer house looked like a fairy-tale castle with its round tower, intricately carved dark wood, and gracious lawn stretching out to a babbling brook called Camp Creek. From the front patio I saw some of the strange red-rock formations that dotted the area known as the Garden of the Gods. Behind the house, through Queen's Canyon, named after General Palmer's wife (isn't that romantic?), a river tumbled over water-smoothed rocks. As we rode or walked, the general talked about what we saw. "Looky here," he'd say as he pointed out the tiniest things: animal tracks hidden among the foliage, a hawk's feather tangled in the branch of a fir tree, a brown lizard darting

COLORADO SPRINGS TODAY

Colorado Springs, located about sixty miles south of Denver, is Colorado's second largest city. Founded as a resort town, it has always been a popular tourist destination. The beautiful scenery and many natural wonders provide year-round activities for today's visitor. Among the most popular attractions are Cave of the Winds, an underground passageway through chambers rich with stalagmites, stalactites, crystal flowers, and limestone canopies; Pikes Peak Cog Railroad, a nine-mile track leading to the stunning summit of the 14,110-foot peak; and the Air Force Academy, four-year home to men and women undergoing rigorous training to become Air Force officers.

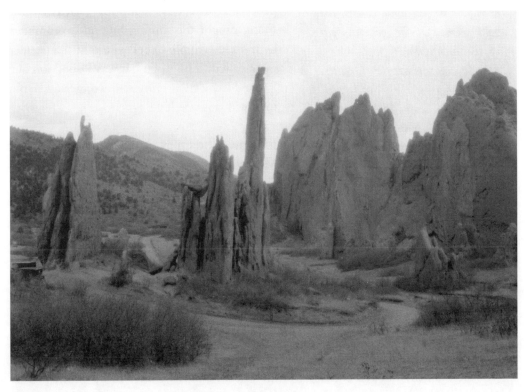

Garden of the Gods near Colorado Springs, Colorado. Taken the 1920s. Photograph courtesy of the Denver Public Library Western History Collection.

GOLD IN THEM THAR HILLS

Cripple Creek is located on the southwestern slope of Pikes Peak, just over the mountain from Colorado Springs. Bob Womack, a full-time cowboy and part-time prospector, discovered gold there in 1890. Because he is known for his way with a story, no one gave Bob's claims much attention. But this find was the kind that couldn't be ignored for long. Soon the gold seemed to be pouring out of the mountain. Cripple Creek became known as the Greatest Gold Camp in the World, ultimately producing $500 million worth of gold. By the way, Bob sold his claim for a couple hundred dollars before he knew the true value of his find. Poor Bob!

under a rock. Thanks to General Palmer, I started paying close attention to the world around me.

EMMA, LAURA'S MOTHER: SPRING 1900

My husband, Frank, never seemed to settle in for long, always wanting to try something new. Thank goodness he liked Colorado Springs. The people there were so nice and treated us real special, too. Well, after all, Frank was related to William Gilpin, the first governor of the Colorado Territory. We rented a house in a proper neighborhood and met all the right people. I kept busy with my charity work. Frank caught the mining bug and commuted by train to Cripple Creek where he managed a mine called "The Lillie." It was a good job but I found myself worrying and wondering, How long will this one last?

LAURA: 1903

My twelfth birthday was the best ever. My favorite present? A Brownie camera! It didn't look like much more than a box with a lens poking out of one side. It was small and easy to use so I took that camera with me everywhere until my friends begged, "No more pictures!"

After my mother and father realized how much I liked photography, they gave me the equipment to develop my own pictures. Right away, I fixed up a makeshift darkroom. Through trial and error and just plain not giving up, I taught myself how to use that equipment. Father teased me, saying I smelled like a vat of stinky chemicals. I did, but I didn't care. I liked the quiet of the darkroom, enjoyed the calm rhythm and regularity of the work. I especially liked to watch the photograph slowly emerge on the paper, although it was hard not to feel discouraged when the picture on the paper didn't match the picture in my head.

LAURA PERRY: ST. LOUIS WORLD'S FAIR, SUMMER 1904

Little Laura Gilpin traveled with me to the World's Fair in St. Louis. She came as my guide and companion. I needed someone to help me around since I'm blind. I chose Laura because Emma, my best friend, worried about her growing up wild and uncultured in Colorado Springs. Emma shouldn't have fretted. That child proved to be a delight, interested in everything that went on around her and of course, always laughing and ready for fun.

LAURA

First of all, let me remind you that "little Laura Gilpin" was thirteen years old during the summer of 1904, practically a grown-up. And let me also say that I loved every single minute of the fair. Who wouldn't? I'll never forget the first day I led Mrs. Perry into the fairgrounds. The exhibition buildings weren't tents but big brick structures made to look like they'd been there for a long time. I especially liked to see the exhibits from the sightseeing boats that floated up and down the waterways of the fair.

I experienced new sights and sounds every day as I helped Mrs. Perry. But I did more than just lead her from exhibit to exhibit. I described everything I saw. Thanks to my walks with General Palmer, I already knew the difference between looking and really seeing. But with Mrs. Perry I not only had to notice details, I had to describe them well enough so that she could picture them in her mind. Try it sometime—it's harder than you think! I learned a lot about patience on that trip.

Plus, I learned a lot about photography. Thank goodness I had my camera! I wanted to remember everything and be able to share it with my family back home.

EMMA: SPRING 1905

I took six-year-old Frances and fourteen-year-old Laura to New York City. Even though we lived in the West, I wanted them to experience the cultural benefits of

"SAY CHEESE, PLEASE"

Laura's mother was lucky to get an appointment with Gertrude Käsebier, the premier woman photographer of her day. Interestingly enough, Gertrude didn't even start taking pictures until her mid-thirties, when she first set up a camera to take photographs of her children. That first meeting with Laura in 1905 was just the beginning of their relationship. Over the years, Gertrude generously acted as cheerleader and mentor to Laura.

School Days

Like many children growing up in the West, Laura attended an elite eastern boarding school in order to learn the social graces and etiquette of the day. She signed up for the "general course," a program designed for students not planning on attending college. Although not a superior student, Laura was an active member of the student body, at various times serving as the class secretary, a member of the glee club, and captain of the field hockey team.

Laura: Spring 1905

Mother was right about the hustle and bustle of New York City. I liked it a lot. But I have to admit, the sky seemed so much smaller there. The tall buildings fenced in the clouds. I missed the wide-open spaces of Colorado.

While we were in New York, Mother commissioned a portrait sitting with the famous photographer Gertrude Käsebier. I think Mrs. Käsebier liked us, especially after she found out that we were visiting from Colorado. She said she grew up there a long time ago. I sure liked her and I loved being in her studio. I told her all about my own photography. She listened while she bustled around, adjusting the background and the light and fiddling with our poses. "Maybe someday . . ." I daydreamed as I watched her.

As she walked us to the door when our session was over, Mrs. Käsebier said, "Let me know if you ever need any help with your photography." I floated on a cloud all the way back to our hotel room, dreaming of the time I might have my own studio.

Frank: Fall 1905

As soon as Laura returned, Emma bustled her right back out of the house again, this time to boarding school. Emma insisted that Laura would get a better education back east. So back east she went. She didn't mind too much, although I saw her slip some western clothing and books into her traveling trunk when Emma wasn't looking.

Friend: Colorado Springs, Summer 1908

We thought Laura might come back all stuck-up from her fancy eastern schools, but she didn't. Laura stayed the same, always looking for adventure and fun.

"Who wants to play?" she would ask, trying to organize a hike or get a field hockey game going.

While the rest of us girls worried about boys and clothes, Laura was learning to drive an automobile. Can you imagine trying to handle one of those crazy contraptions? She not only drove one, she worked on the engine. We teased her about it but she shrugged and said she liked fiddling with mechanical things. I guess she liked getting covered with grease, too, because she certainly did whenever she stuck her head under the hood.

Laura: Winter 1911

School, photography, family, and friends. My life clipped along pretty smoothly until Father decided to give up mining and try ranching again. Mother wrote me at school telling me to come home. I helped her pack our belongings and then we all moved farther west, following Father's dream across the mountains to an 1,800-acre spread in Austin, Colorado.

Time hung heavy with no school and no friends. "I might as well make some money," I thought and decided to start my own business. After considering several possibilities, I settled on raising turkeys to sell to fancy restaurants and stores.

Frank: Spring 1912

My, oh my, Laura never did anything halfway. She threw herself headfirst into every project, and this one was no exception. We'd barely settled in before she

Turkey Tales

Twenty years after Laura first made a success with her turkey business, she started it all over again. Like many others around her, Laura struggled financially during the Depression. In 1935, desperate to make some money, she and a friend opened the Fairfield Turkey Farm on three hundred acres of land outside of Colorado Springs. They specialized in piñon-fed gourmet turkeys for expensive restaurants throughout the country. Laura's business reputation was unexpectedly boosted when a wealthy European baroness, hosting a highfalutin' party, ordered turkeys from the 21 Club in New York. Very fancy! When the turkeys arrived, they sported the tag of "Fairfield Turkey Farm."

took over one of the buildings on the property. It tickled me to see her out there hauling lumber, sawing boards, and hammering nails. She built the turkey pens herself and got that little building looking right smart. Then she bought the chicks and got started. Laura took care of the business from start to finish. Why, she fed those turkeys, cleaned their cages, and in the end killed them and got them ready to ship. Of course, her mother was fit to be tied. Seeing Laura mucking around in the mud, chasing after turkeys, didn't fit Emma's fancy ideas. But soon enough, after lots of hard work, I'll be darned if Laura's business didn't take off and that girl of mine started making money.

SCHOOL IS COOL

Laura's education at the Clarence White School of Photography was divided into three main areas of study. Four mornings and two afternoons a week she took White's Class in the art of photography. The curriculum covered topics like camera selection, night photography, and color printing. Another instructor taught art appreciation and design two times a week. In addition, Laura took a third class in techniques in photography.

LAURA: WINTER 1915

I liked having my own money. It made me feel independent. Besides, I needed that money so I could keep up with my photography. I set up a darkroom in another building on the ranch and whenever I could sneak away from my turkeys, I practiced taking and developing photographs.

Everything was going well until Father got antsy yet again. Back to Colorado Springs we moved. Even though I had to sell my business, I was happy to see my friends. But I realized then and there that I needed to move forward with plans for my own life. Depending on Father was like depending on a mirage.

EMMA GILPIN: FALL 1916

Of course, Laura loved photography. She had since she was a little girl. She decided that this was the time to move forward with her own dreams. Summoning up her courage she wrote a letter to Mrs. Käsebier asking for advice. That nice woman wrote right back recommending the Clarence White School of Photography in New York City.

No sooner said than done. Laura arranged everything. Thank goodness for that darned turkey business. Laura paid for her schooling with her own money. Good thing, because we sure couldn't help her.

Neighbor: Fall 1916

We saw the Gilpins coming home from the train station. Poor crying, red-eyed Emma. "If a girl gets married, she doesn't have to worry about a career. Maybe instead of going to school, Laura should spend time looking for a beau," I suggested, trying to be helpful. Emma glared at me and then stomped off into the house.

Laura: 1917–1918

I loved studying in New York. How could I not? All day, every day, devoted to photography! After a long day of classes, I came home exhausted, my head full to overflowing with all the new things I'd learned.

Client: Summer 1919

We heard Laura Gilpin was back in town, working as a photographer. We knew the Gilpins from the Cheyenne Mountain Country Club. As usual, they were struggling to get by. Just to be nice, really, I arranged to have Laura take our portrait. I knew they needed the money. But as it turned out, we thoroughly enjoyed working with her. What a nice young woman! And the portrait she took? Lovely! Very artistic. We hung it above the fireplace.

Clarence White — What a Guy

Clarence White, beloved teacher to many, opened his school in 1914. He believed in photography as fine art, but also believed in using photographic images commercially for advertising, graphic design, and magazine journalism. He saw the career opportunities this new technology offered to women, encouraging many, including Dorothea Lange, to pursue photography as a business. Laura greatly appreciated the education she received from Clarence White and later described him as "one of the greatest teachers I have ever known in any field."

Laura: Summer 1919

"A career doesn't happen overnight," I told myself, frustrated when jobs seemed few and far between. I kept submitting my work to photography exhibitions, hoping to generate sales, but mostly I pounded the pavement looking for work, taking whatever came my way. I couldn't afford to be picky. I did portraits, advertisements, and company brochures. Some photographers think they are above that kind of work. Sure, I preferred landscapes or fine art photography, but the truth is, I had to eat. And Mother and Father were beginning to count on my income, too.

Visitor to London Exhibition: 1921

I saw a photograph at the exhibition in London by an American photographer—a woman. I didn't know women did landscape photography. But by jove, I liked her work. Large, pillarlike spires cloaked in a thick mysterious fog. Amazing! The photograph was taken at a place called Garden of the Gods. Nothing like that in England!

Painting or Photo?

From Clarence White, Laura learned a particular style of photography called pictorialism. This hazy, rather romantic approach to picture taking treated photographs as paintings. Pictorialists believed in manipulating the reality seen through the lens in order to create a certain mood. For instance, in her 1917 print of a snowy Central Park, Laura painted a man out of her negative because his presence detracted from the quiet, isolated mood she was trying to achieve. As Laura's expertise and confidence grew, she abandoned the pictorial style for a more sharp-focused, straightforward approach to photography.

Friend: Summer 1922

What's the big deal? How hard can it be to take a photograph? I thought. That is, until I went out with Laura while she took one. We left Colorado Springs one Saturday, bouncing along a bumpy dirt road deep into the mountains. "This is the place," Laura said finally, pulling the auto off the road. We set up camp by a sweet little brook in the cool darkness of a cluster of blue spruce. The ground, softened by a thick layer of pine needles, made a soft mattress for our blankets. I wandered near camp, threw rocks across the river, and sketched wildflowers. But not Laura.

Laura

I hiked up to the summit, to a high mountain lake I'd seen earlier in the summer. With the wildflowers in bloom and wispy white clouds streaking across the blue sky, the scenery looked even better than I remembered it. I started planning my photograph and hoped the next day's weather would cooperate.

Some people think a good picture just happens, and sometimes, if I'm lucky, it does. But most of the time a good picture takes planning, thought, and technical knowledge. First I think about what I want the finished photograph to look like, what kind of mood I want to create. Then I think about which camera to use, which filter, and how to best achieve the effect I want.

My mind raced as I walked around the lake, imagining the photograph from

one angle and then another and another. What if I put my camera closer? I thought. What if I move it farther back? Do I want to include the whole peak or just some of it? Can I get the reflection of the clouds in the lake? I hope it's not windy tomorrow.

FRIEND

"Are you done yet?" I asked when Laura tramped into camp as the sun dipped behind the mountain. "I'm never done," she said, plopping down in front of the campfire and dished herself up some of my delicious stew.

The next morning, Laura woke me up before dawn, laughing when I complained about the cold. But when I threatened to crawl back under my covers, she said, "Trust me, it will be worth it when the sun comes up."

We hiked in the steel-gray light. Without a trail, I stubbed my toe on rocks and clumsily stumbled over fallen logs. Laura looked like a pack mule loaded down with her camera equipment. The awkward bundle didn't slow her down, though. "Wait for me!" I called.

BEING EXHIBITED

Laura worked hard at getting her photographs included in exhibitions around the world. Usually, for a beginner that meant submitting selected prints for review to a committee and then hoping, with fingers crossed, that the prints were accepted. The larger and more well-known the exhibition, the more prestige came with being included in the show. In 1920 alone, Laura's work was shown in fourteen group exhibitions.

LANDSCAPE PHOTOGRAPHER

In his book Why People Photograph, Robert Adams had this to say about Laura's experiences of being a landscape photographer: "As to whether she had a more difficult time as a landscapist because she was a woman, I'm positive that she did. Just to be forced, for example, to be more concerned with one's safety would be a serious additional burden while photographing." Adams also pointed out that landscape photography often required days spent hiking in and out of hard-to-reach locations, carrying heavy equipment over difficult terrain, and being away from one's family for long periods of time.

LAURA

When we got to the lake, I quickly set up my camera and then waited for the exact right time to take the photograph.

FRIEND

And at the exact moment Laura went to take her photograph, a cloud came over the sun. "All that work for nothing," I moaned. Laura laughed. She said just seeing the sunrise was worth the effort.

LAURA: FALL 1924

"We're going on an adventure," my best friends Betsy and Brenda sang as we packed. "Hardly any room for people," my father said, looking over my old Dodge, full to overflowing with camping equipment, suitcases, books, art supplies, and of course my cameras. Tooting the horn and singing, we waved good-bye as we drove through town.

The trip to Mesa Verde, Colorado, took three days. Three days of dirt in our teeth and wind roaring in our ears. We sang songs, shared secrets, and told stories to pass the long hours of driving. My old Dodge performed like a real trooper, lurching its way up steep passes, joggling over bumpy twisting roads, and finally, as we neared Mesa Verde, spitting and sizzling like a cranky old cat.

BRENDA

That Dodge wasn't the only one feeling cranky. Laura, our tireless driver, sometimes forgot that we were not all Rocky Mountain–born. She loved driving up and over those windy, narrow passes. I didn't. The worst was Knife's Edge, the road leading to the ruins. Narrow, sharp, and dangerous! "There's nothing to worry about," Laura reassured me calmly, but I found out later that more than one automobile had toppled over the edge.

LAURA

What an amazing sight! I will never forget my first view of the magnificent ruin called the Cliff Palace. Huddled under the protective stone lip of the mesa top,

The cliff dwellings of Mesa Verde are located in the part of Colorado known as the Four Corners region; this is the place where Colorado, New Mexico, Arizona, and Utah meet. The first signs of human life in Mesa Verde itself can be traced to A.D. 500, although scientists believe that human beings lived here long before this. The ancient Indians lived in pit houses, made crude pottery, and grew corn and squash for food. The culture developed over the next 700 years, until by 1250, the Indians called the Ancient Puebloans were building great stone cities inside the cliffs.

bathed in the golden glow of the afternoon light, the huge rock village sat in stony silence.

Later on, when we hiked along the canyon floor, our path followed the natural curves of the canyon walls. A black crow circled above me, calling out a raucous greeting. My boots kicked up the dry dirt and I wondered at the skill and patience required for farming such dry, harsh land. As we walked I noticed the sharp spines of a yucca plant, the gnarled branch of a juniper tree, and in the distance, a mule deer grazing behind a piñon tree. With so much to see I couldn't wait to start taking pictures.

BRENDA

At night we sat around a campfire and listened to the park ranger tell stories about this place and its people. The firelight flickered and danced across the walls and ceiling of the cliffs, and our shadows loomed large against the brick walls of the ruins. Beneath us the valley lay dark and silent.

LAURA

I got up early to wander alone with my camera. The early morning light slanted across the cliffs, casting long shadows through the rock windows and doors. As the sun climbed higher in the sky, I sat against a cold sandstone brick wall and listened to the quiet. The mystery wrapped itself around me and for a few minutes I think I almost heard the murmurings of the long-lost culture of the ancient ones who had lived here seven hundred years ago.

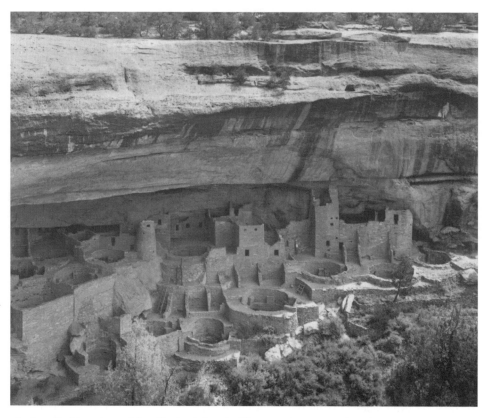

Ancient Pueblo ruins at Mesa Verde, Colorado. Photograph courtesy of the Denver Public Library Western History Collection.

RICH HISTORY

On a trip to Europe in 1922, Laura spent a great deal of time visiting museums to admire the art and relics from the past. At the Bodleian Library at Oxford University, she saw an early globe with Santa Fe the only spot identified in the vast lands of the American West. Impressed with the rich history of her little corner of the world, Laura wrote in her journal: "The romance of the Old West vanished so fast and so few ever did anything with it. Does it make you realize the importance of Art, and how the main knowledge of history is through Art alone?"

My heart swelled with pride over the rich history and beauty of my little corner of the world. I felt lucky to have seen the sights I had on my travels. *Why not make a book?* I thought. Mesa Verde? Pikes Peak? Garden of the Gods? The prairie? A book illustrated with my photographs and written with my words. A book where I shared my vision and love of the West. The more I thought, the more excited I felt. I knew I had found my next project!

❧ *Afterword* ❧

As ALWAYS, IT didn't take long for Laura to follow up on her idea. When she returned from her trip, she formed her own publishing company and began working on her project, a twelve-page brochure of the Pikes Peak region. When it was completed, Laura sold it to tourists for the relatively high price of one dollar. Although only a moderate success financially, this project launched Laura in a new direction, one her photography would take for the rest of her life.

WILLA CATHER, TOO

*L*aura wasn't the only woman artist to be moved by a visit to Mesa Verde. In 1925, Willa Cather, the American writer, published her book* The Professor's House. *The fictional hero of her story, Tom Outland, visits Mesa Verde, lamenting the fact that "we had only a small Kodak" to take in the incredible beauty of the site. Forever the entrepreneur, Laura tried unsuccessfully to contact Cather about creating an illustrated version of the book, using her own photographs.*

Over the years Laura traveled a great deal and wrote several books. She continued to do commercial work in order to support her true passion, landscape photography.

Laura never became rich from her photography. Nor did she become famous. What she did do, however, was continue to work hard at a profession she loved. Laura wanted to do something more than just take pretty pictures, and she did that, too. Through her books and photographs she introduced Americans and people around the world to the West.

As a young woman visiting Europe for the first time, Laura wrote home, saying, "The more I see of the rest of the world, the gladder I am that I am not only American, but a Westerner." Laura Gilpin never changed her opinion of the West and spent the rest of her life taking photographs of the land she loved best.

Photograph by Laura Gilpin titled, "Rio Grande Yields Its Surface to the Sea," gelatin silver print, 1947, 8^{11}/_{16} x 13^{3}/_{4} in.

∾ *Bibliography* ∾

Adams, Ansel. *Example: The Making of 40 Photographs*. Boston: Little, Brown, 1983.

Adams, Robert. *Why People Photograph: Selected Essays and Reviews*. New York: Aperture Foundation, 1994.

Forster, Elizabeth W., and Laura Gilpin. *Denizens of the Desert*. Albuquerque: University of New Mexico Press, 1988.

Gilpin, Laura. *The Enduring Navaho*. Austin: University of Texas Press, 1968.

Horwitz, Margot F. *A Female Focus: Great Women Photographers*. New York: Franklin Watts, 1996.

Norwood, Vera, and Janice Monk, eds. *The Desert Is No Lady: Southwestern Landscapes in Women's Writing and Art*. New Haven, Conn.: Yale University Press, 1987.

Sandweiss, Martha A. *Laura Gilpin: An Enduring Grace*. Fort Worth, Tex.: Amon Carter Museum, 1986.

Dorothea Lange

(1895–1965)

DOROTHEA LANGE PHOTOGRAPHED people. She had a talent for finding and capturing a single image that spoke volumes about the world's problems. In a photograph of a mother holding her young children, Dorothea showed the suffering brought on by the Depression better than a whole book of facts and figures. Her photographs weren't meant to be pretty, they were meant to arouse deep feeling, to teach, and to prod the viewer to action.

When drought and dust storms hit the Midwest, crops failed and thousands of people lost their jobs, their farms and their homes. Many of these people looked to the West as a place to find work. During the 1930s, in one of the largest migrations in the United States' history, 750,000 farmers traveled to California, Oregon, and Washington. Although they came desperate to find work, mostly they found poverty and hopelessness. With compassion, respect and complete honesty, Dorothea recorded their suffering. By combining the "eye" of the artist with real life situations, she created not just art for art's sake but, as George P. Eilliot said, "art for life's sake."

Maybe Dorothea was good at capturing the suffering of others because she had experienced so much suffering herself. Born Dorothea Nutzhorn on May 25, 1895, in Hoboken, New Jersey, she contracted polio at age seven. Although Dorothea recovered after a long illness, she walked with a limp for the rest of her life. Just five years later, when she was twelve, Dorothea's life was set in turmoil once again when her father walked out on the family.

Never a dedicated student, as Dorothea got older she liked school less and less. In high school she often didn't even attend class and instead spent her days wandering the streets of New York, visiting museums and attending concerts.

After she graduated from high school, she decided to be a photographer, even

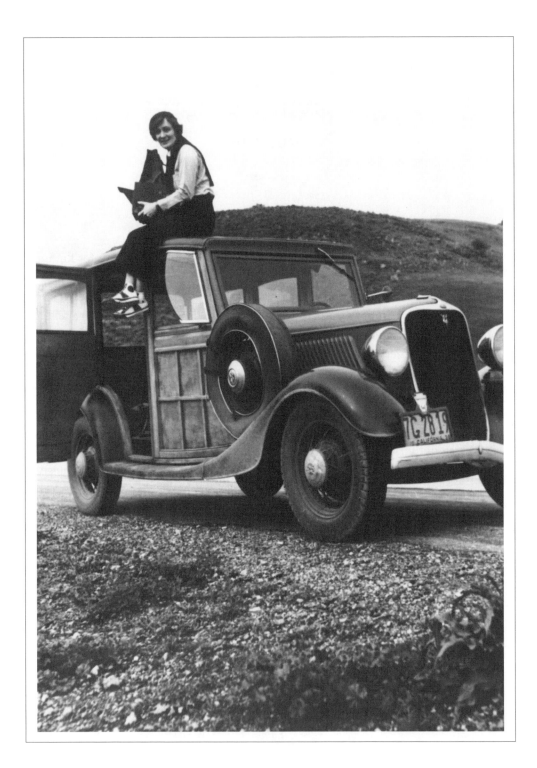

though she had never taken a photograph. To educate herself Dorothea worked for various photographers in New York City. After several years, she had the skills and experience she needed to get a job. That was the plan when she and a friend, Fronsie Ahlstrom, set off for a trip around the world.

FRONSIE: JANUARY 1918

In preparation for our big adventure, Dorothea and I pooled all of our money, $140 between the two of us. We couldn't wait to get out and experience the world. Her mother didn't ap-prove, nor did mine, but we left anyway, sure of our plan and our ability to take care of ourselves. We took a boat to New Orleans and then traveled by rail to San Francisco. We fig-ured we'd just keep traveling until we ran out of money.

DOROTHEA: SAN FRANCISCO, MAY 1918

The end of our travels came a little earlier than expected. In San Francisco we were robbed. Some thief took our money—all of it! Right out of my purse. That was it for our trip. I didn't mind, though. Of all the places to get stranded, San Francisco wasn't half bad. I liked the energy of the place, big and crowded and noisy. I liked the way the trolley clanged its bell as it rattled and lurched up and down the hills. And I especially liked the excitement of being out on my own.

FRONSIE: SAN FRANCISCO, MAY 1918

The first order of business was to get a place to stay. A friend told us about the Mary Elizabeth Inn, a boardinghouse where working girls could live cheaply and safely. We checked in right away. The rooms were clean and tidy, but we soon

BOARDINGHOUSE BLUES

Although by 1918 more women were working and earning a living, Dorothea and Fronsie were a bit unusual in that they weren't living at home with their families. The idea of young, unmarried women living alone in a big city was still somewhat new, and thus there weren't as many options for housing as there are today. Boarding houses gave young, single women a respectable, chaperoned, safe place to stay at a reasonable price. The rent included their own bedroom and scheduled meals. Other public rooms, including the bathroom and sitting room, were generally shared by all.

OPPOSITE: *Dorothea Lange at work, 1936. Farm Security Administration—Office of War Information Photograph Collection. (Library of Congress).*

Good Friends for Life

*D*orothea said that her job at the photo-finishing counter *"was the beginning of my life here."* It certainly was the beginning of a lifelong friendship among Dorothea, Roi Partridge, and Imogen Cunningham. For the next fifty years these friends and their families shared confidences, vacations, and child-care responsibilities, eventually seeming more like an extended family than just friends. Roi and Imogen's son, Ron, became Dorothea's apprentice and right-hand man when she started working for the government almost twenty years later.

found out that living there required following a million rules: *No smoking. Be in by ten. No gentleman callers.* So much for our independence.

DOROTHEA: MAY 1918

"Once we get jobs we'll move to an apartment," I said. Luckily, by the evening of our second day in San Francisco, both of us were working girls—Fronsie with Western Union and I at the photo-finishing counter of a camera store. Good thing, too. I didn't want to obey someone else's rules anymore. After all, I was twenty-two years old, a grown-up. And besides, there were just too many things to see and do to be tucked in bed by ten. Can you imagine?

ROI PARTRIDGE: MAY 1918

I met Dorothea on the first day of her job at the photo-finishing counter. I'm an artist, and my wife, Imogen Cunningham, is a photographer. I liked Dorothea the moment I met her. Imogen liked her, too. We introduced Dorothea to all of our friends. People in San Francisco called us the Bohemian crowd, mostly because we were artists and because we dressed and acted the way we wanted. Dorothea fit in right away.

DOROTHEA

Moving to San Francisco gave me a fresh start. Why not take advantage of it? Since no one knew me, I dropped my father's last name. I didn't want to be a Nutzhorn. That name linked me to the man who abandoned me. I changed my last name to Lange, my mother's maiden name. I had a new life in a new city. Why not start out with a new name, too?

IMOGEN CUNNINGHAM: SAN FRANCISCO, 1918

I don't think I ever heard Dorothea talk about her father. I knew nothing about him.

IMOGEN CUNNINGHAM

When Dorothea met thirty-two-year-old Imogen Cunningham, Dorothea was just starting out in her career while Imogen was already a well-established photographer doing both commercial and artistic work. Her photographs were exhibited and sold throughout the world. Interestingly enough, although Dorothea viewed Imogen as an artist, she viewed herself as a "tradesman." In other words, Dorothea felt that taking portraits of people wasn't actually artistic but instead just the technical completion of a task that anyone could learn.

One thing I did know, though. Dorothea hated her limp, believing it made her look weak. It embarrassed her. She spent a lot of time trying to hide it and wore long, full skirts or pants to cover it up. She thought learning to dance would help her move with less of a limp, and she talked me into taking dance lessons with her.

DOROTHEA: 1918

I'm not sure whether the dance lessons helped my walking, but they did increase my self-confidence. I felt less awkward when I moved, more sure of myself.

INVESTOR FRIEND: 1918

Dorothea always seemed plenty sure of herself to me. I met her through a camera club where we both belonged. I saw her photographs and knew she was good. When she told me that she wanted to start her own studio, I said I'd help. It seemed like a no-fail investment if you ask me. I never doubted Dorothea for a single second.

POLIO

Dorothea came down with polio, an infectious viral disease, before the polio vaccine was invented. After the illness was over, she was left with some paralysis in her right leg. She couldn't flex the front part of her foot, and as a result she walked with a limp. When talking about her disability later in life, Dorothea said, "I think it was perhaps the most important thing that happened to me. It formed me, guided me, instructed me, helped me and humiliated me. All these things at once. I've never gotten over it and I am aware of the force and power of it."

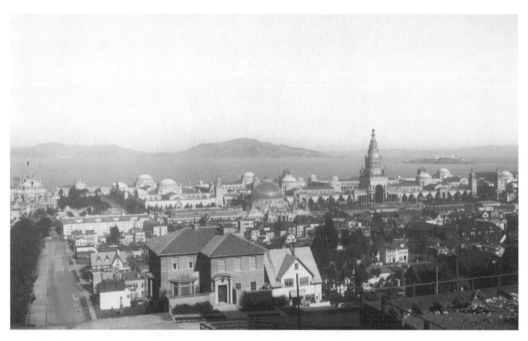

A view of San Francisco looking out over the bay, with Alcatraz and Angel Island in the distance. Taken in spring 1915. Photograph courtesy of the Denver Public Library Western History Collection.

Once she got started, I was even more convinced of her good business sense. She set up an elegant studio, with a black velvet couch in front of the fireplace, fluffy down pillows, and vases of beautiful, luxurious flowers spread about the room. Then she hired an assistant, set up a darkroom, and started taking pictures.

RICH CLIENT: 1919

Well, my dear, my friend went to Dorothea to have a portrait taken and just *loved* her. And she *loved* the photograph Dorothea took. She said I must get mine done, too, so I did. Dorothea made me feel like a regular princess. During our first meeting that sweet girl never even took my picture. She just asked me questions about myself, my family, my life. And she listened, really listened, to my answers. By the time she finally did get out her camera, I felt totally at ease. I trusted her to take a portrait that showed the true me.

DOROTHEA: 1919

I was determined to succeed and worked hard—very, very hard. Everything had to be just right. Perfect, really. I worked long hours, evenings, weekends, and even

holidays. I took the pictures, developed them, retouched them, and sometimes even delivered them. Building a business isn't luck. It's pure hard work.

IMOGEN CUNNINGHAM: 1919

Oh, that was a glorious time. All of us were absolutely crazy about our work, crazy about our friends, and crazy about living in San Francisco.

Dorothea started a tradition of serving tea every afternoon at 5:00 in her studio. Such a lovely idea. Her assistant made the tea in a large brass teapot. People stopped by for a snack and lots of great music and company. If I was in the neighborhood, I always dropped in. And believe me, I *always* tried to be in the neighborhood.

DOROTHEA

People often arrived while I worked downstairs in my darkroom. Sometimes I joined them and sometimes I stayed put and did my work accompanied by the laughter and music

upstairs. Thanks to one of those afternoon tea parties, I met Maynard Dixon. Of course, I knew about him long before I met him. He was a sort of celebrity in our crowd, an artist who painted the landscape and people of the West. And he certainly looked like a cowboy: tall and lean and handsome. He dressed in jeans and cowboy boots. At first he intimidated me, but when I got to know him I liked him. Obviously he liked me, too. When we decided to get married, some of my friends tried to talk me out of it, considering the age difference, but as those same friends will tell you, it's hard to talk me out of anything once I've made up my mind.

MAYNARD: SPRING 1920

People said I was too old for Dorothea. She was twenty-four and I was forty-five when we married. But we hit it off and the age difference didn't matter to us. Dorothea respected my work and understood how the need to paint drove me.

TRAVELING MAN

Maynard often traveled to the Southwest for his sketching trips. In the summer of 1922 he took Dorothea with him to Arizona. For four months they lived at a trading post on the Navajo Reservation, in the small town of Kayenta. During that time they explored the Four Corners region. In the summer of 1923 they returned to Arizona, camping at the base of Walpi Mesa on the Hopi Reservation.

I warned her about our life together. I told her straight out that I didn't plan on staying home to play with babies. I told her I wouldn't help with housework and worry about the bills. "I'm an artist," I said.

After we married, I often went on painting trips out into the wilderness. Sometimes Dorothea came with me, but mostly she didn't.

DOROTHEA: SAN FRANCISCO, SPRING 1928

When we first got married, I did travel with Maynard. We had a good time together. But as the years passed, I went with him less and less. I couldn't afford to, frankly. What about my business? The money I made from my portrait studio paid the bills when Maynard didn't sell his paintings or when he was gone for months at a time. And what about the babies? Dan was born in 1925, and John in 1928. I couldn't very well just up and leave because Maynard got a hankering to go out and paint the wilderness.

I must admit, I felt lonely when he left. Lonely and, well, envious. I saw that Maynard had the luxury of leaving. He came and went as he pleased. I couldn't. I was the responsible one, a mother and a businesswoman. I felt as if my work kept me from being a good mother, and I know being a mother kept me from devoting myself to my work. I often had to choose between the two. Sometimes my work won and sometimes my family did. Whichever choice I made, though, I felt guilty.

MAYNARD: SAN FRANCISCO, 1928

Why couldn't she just be happy being my wife, being the mother of my children? Why wasn't that enough?

DOROTHEA: CALIFORNIA, SUMMER 1929

One summer afternoon, when the boys and I had accompanied Maynard on one of his sketching trips into the mountains, I took off by myself. I found a big, sun-warmed rock and stretched out like a cat, to soak in the sun. I needed time to think about the direction of my work. I wanted to do something more than just portraits

Caught Between

*I*n the 1920s, women seemed to be caught between two worlds. During World War I, many women filled jobs vacated by soldiers away at war. When the war ended, a new generation of women had tasted life in the workplace and liked it. They wanted to work, and as in Dorothea's case, the family depended on their income. But society felt that jobs outside the home interfered with a woman's primary job of caring for her husband and children. As Dorothea found out when she had children, her schedule, responsibilities, and ambitions were supposed to take a backseat now that she had a family. Dorothea always felt like she was walking a tightrope between being a good mother, an artist, and a businesswoman.

of rich people, but when I tried other types of photography—the types my friends did—I wasn't very good.

I watched some storm clouds pile up in the distance. As they got closer, the towering clouds caught the afternoon light, casting a yellowish green color over everything. When the storm broke, the rain lashed against me, the thunder ripped apart the sky above me, and the wind whistled through the trees. And there in the midst of this wild, roaring storm I felt calm because it came to me that I didn't need to worry about photographing flowers or landscapes or scenery. My focus, from that moment on, had to be only on people. Rich people who could pay me for portraits and poor people who couldn't, inside the studio and outside, posed and smiling, unposed and suffering. I guess, looking back, that storm was a turning point in the direction of my life.

Maynard: San Francisco, 1929

October 24, 1929. I'll never forget that day. The stock market crashed and life in America changed overnight. As artists, Dorothea and I were deeply affected. After all, if people couldn't afford to feed their families, they certainly couldn't afford to have a portrait taken by Dorothea or buy a painting from me.

The uncertainty darn near killed me. Why, if the bottom could drop out of our lives overnight, it felt like anything could happen. No one knew what to expect. "Surely this won't last," some people said, but each day the situation looked worse and more frightening than the day before.

DOROTHEA LANGE · 57

DOROTHEA: 1931

As months and then years passed, the Depression deepened. People's moods darkened. But life goes on. Maynard continued to go out on his sketching and painting trips. I kept my studio open and made enough money for us to get by. Sometimes I gathered the boys up and we'd go with Maynard on one of his trips. It helped to get out of the city.

DANIEL: 1932

I loved my mother and father and knew they loved me, but the Depression made it hard to be a family. When my brother, John, was four and I was six, my mother enrolled us in a boarding school. Mom and Dad came every weekend to visit, but it wasn't the same. I missed them all week long.

DOROTHEA: 1932

I saw suffering people everywhere, homeless, ragged, and hungry people. The life I saw out on the streets seemed more real and more important than the sheltered life I led inside my studio.

One day, as I looked out my studio window at an unemployed man wandering aimlessly by, I remembered that afternoon in the thunderstorm when I saw my future so clearly. If not now, when? I thought. So, right then and there, I grabbed my camera and went out on the street. I didn't know what kind of picture I was looking for. I just followed my instincts and went.

It took me about one minute to realize that this type of photography was completely different from what I normally did. In the studio I was in control. If I didn't like a pose, I changed it. "Move your arm,

smile bigger, put your hands like this," I'd say. Not out on the street. I didn't have time. Life happened and I had to get it on the fly.

That first day out, I took one of my most important, most famous photographs. I named it *White Angel Bread Line*.

MAN IN BREAD LINE

Sure, I remember that lady photographer. I might be poor but I'm not blind. As I stood there in line, I watched this lady come close, lugging this big, heavy camera. She started taking pictures of all us down-and-outers in the bread line. Later on, I saw the picture she took that day. And you know what? I liked it. Didn't expect to, but I did. The photograph didn't make us look like bums. It just showed how we felt waiting for handouts, knowing that a few

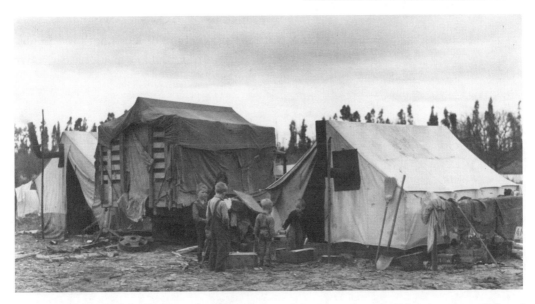

Typical migrant camp in California, 1936. Courtesy of the Farm Security Administration—Office of War Information Photograph Collection (Library of Congress).

FOLLOW YOUR DREAM

After Dorothea hung her picture of the White Angel Bread line in her studio, people repeatedly asked her, "Why are you doing this? And "What are you going to do with a picture like that?" Although Dorothea couldn't answer these questions, she also couldn't give in to their doubts. Later in her career, when her work was known and respected throughout the world, she remembered these questions and would tell young photographers not to let other people's doubts stop them, "because ways open that are unpredictable, if you pursue them far enough."

years before, we had our own tables in our own homes filled with bread bought with the money we had earned with our own hard labor.

DOROTHEA: 1932

I told you, I didn't know what I was doing. Well, I didn't know why I was doing it, either. I followed my instincts and took the picture. After I developed it, I thought, Now what? What am I supposed to do with it? I had no idea so I hung that *White Angel Bread Line* picture on the wall of my studio. Then I waited to see people's reactions.

PORTRAIT CLIENT

Frankly, I detested it. I saw suffering every day in the street. Why look at a picture of it, too? But the truth is, in the streets I didn't really see the suffering. In fact, I tried very hard not to see it. I hurried past those long, winding bread lines full of raggedy men without looking. But that photograph of Dorothea's was impossible to ignore. I couldn't hurry past it. Darn

FDR

On March 4, 1933, Franklin Delano Roosevelt became the new president of the United States. Right away, FDR rolled up his sleeves and got to work setting up his New Deal. One of these new programs directly impacted Dorothea's life. The federal government needed to understand the effects of the Depression before it could ease American's suffering. People like Paul and Dorothea were hired to be their eyes and ears, to bring back information to the various government agencies so that these agencies could make decisions about how to reduce the poverty.

her! The picture made me feel sad. Guilty, too.

"Why waste your time?" I asked Dorothea. "Why waste your talent?"

DOROTHEA: 1933

I couldn't answer her questions, but I kept finding myself drawn to the streets, to take photographs that many people didn't like and surely no one wanted to pay for. All I know is that to me it seemed more worthwhile than any photography I'd ever done.

PAUL TAYLOR: SUMMER 1934

When I first saw Dorothea's street photographs, I thought they were worthwhile. As an economics professor at Berkeley, I was working on a way to improve conditions for migrant workers. Dorothea's photographs were powerful, so emotional. I invited her to come along with me when I went to visit a farming community hard hit by the Depression. Right away I admired the way she worked, not pushy or aggressive but slow and thoughtful with respect and regard for the people she was photographing.

PAUL TAYLOR

When Dorothea first met Paul, they were both thirty-nine years old. A former marine in World War I, Paul had earned a doctorate after the war and worked as an associate professor at the University of California at Berkeley. The driving force in his life was a concern for the poor, and he worked long and hard for what he believed in. During the Depression he was deeply moved by the debilitating poverty of the migrant worker, a poverty often caused by social conditions beyond the individual's control.

DOROTHEA: 1934

I'd never seen a social scientist at work. I enjoyed watching Paul—the way he talked to the people, asking them questions, gathering information. He had a kind and gentle way about him that people liked.

PAUL: 1935

The California State Emergency Relief Administration (SERA) hired me to study why there were so many new migrant workers flooding into California. Once I figured out why the migrants were here and where they came from, they wanted me to find a way to help them. I agreed and then made an unusual request. I wanted to hire a photographer to come along with me out in the field to document my words with pictures. I wanted those government workers to see real faces when

What Is a Migrant Worker?

A migrant worker is a temporary employee hired by a farmer, usually during harvest time, to help bring in a crop. Up until the Depression, migrant workers tended to be unmarried men who spent their lives following the harvest of fruit and vegetable crops.

Starting around 1934, the face of the migrant worker changed. All of a sudden a large number of families were pouring into California looking for work as migrant laborers. Many of these families were from the Midwest. A devastating drought had hit the Midwest and by 1934 crops had withered in the fields and topsoil was blowing away in huge dark clouds of dust. Thousands of families lost their crops, then their livelihoods, and finally their land. Farmers became homeless, piled their families and a few possessions into their cars, and traveled to California hoping to find jobs working for other farmers.

they read my cold hard facts. I knew that together Dorothea and I could produce results. At first the answer was no. They didn't believe that photography had a place in scientific or government work. But finally I won and they hired Dorothea for $1,200 a year.

An Awesome Assistant

Ron Partridge later described what it was like working as Dorothea's assistant: "I don't think we ever drove more than forty miles in a day. I'd be going twenty miles an hour and she'd say, 'Slow down, Ron, slow down.' ... When we saw something—a broken car, a camp of migrants, a farm machine, a field boss—we would stop."

Dorothea: 1935

Paul hired me and we took to the road. We'd drive out in the morning to a camp of migrant workers, study the conditions, and be home by evening developing my pictures. Our days were long and grueling, but I finally felt like I was doing what I needed to do.

Ron Partridge: 1936

I wanted to be a photographer. After my mother, Imogen Cunningham, taught me everything she knew about photography, she sent me to work with Dorothea. I worked as her assistant, helping her lug equipment around and developing pictures at night.

When we traveled, my job was to drive real slow while Dorothea looked

around for just the right setting, her eyes moving from one side of the road to the other, taking in every detail.

Migrant Worker: 1936

When I saw that photographer walkin' toward me, I said, "Oh no, here we go again. Someone comin' to make money from my misery." But then I noticed her limp and I figured she musta seen her own share of misery, so I didn't mind sharin' some of mine.

She told me that she was takin' pictures for the government in Washington, D.C. She said they wanted to see what was happening to us so they could figure out a way to help. I had to say yes to gettin' my picture took after that. If I said no, it'd be like sayin' no to helpin' myself.

Usually people just saw the dirt, the holes in my husband's overalls, and my daughter's bare feet. I'd get the feeling that they thought less of me because we slept in our car and cooked on a makeshift stove. Somehow, though, I felt Dorothea saw past all that, I guess because she talked to me and heard my story. She knew I was more than the dirt and the holes and the poverty.

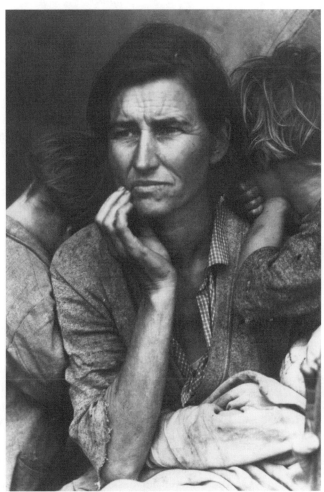

Dorothea: 1936

Sometimes this job just broke my heart. These people had been through so much. Sure, I

This photograph taken in 1936 of a migrant mother in California is one of Dorothea Lange's most famous images. Farm Security Administration—Office of War Information Photograph Collection (Library of Congress).

wanted to give money to every person I met, but I knew that a few dollars wouldn't make a dent in their suffering. Really, the way I saw it, the only way to make a difference to these people was through my pictures. They showed more than words ever could.

Strength in Weakness

People often responded to Dorothea because of her disability. The same was true with President Franklin D. Roosevelt. Both of these two strong personalities suffered from the physical aftermath of their bouts with polio. FDR was paralyzed from the waist down. In fact, after his recovery, it took him years to learn to walk using canes and wearing heavy metal braces around his legs. Even when he did walk, it was with much effort and only for short distances. Instead of the American people seeing his disability as a weakness, however, they viewed it as a strength. They knew that since he had faced suffering in his own life, he could understand their suffering. This is exactly how the migrant workers seemed to respond to Dorothea and her disability.

❧ Afterword ❧

DOROTHEA DID JUST that: she continued to make a difference through her pictures. Thanks to the work she and Paul Taylor did and the reports they wrote, the government set up camps where migrant families could live safely while they worked. Relief and assistance were given in other ways, too.

Dorothea and Maynard divorced in 1935. Although she remained friends with Maynard, she wanted to live with someone who shared her vision of life. Paul Taylor was that man. They married in 1936 and remained together for the rest of Dorothea's life.

The Depression ended just as World War II began. Dorothea went from photographing the lives of migrant workers to photographing the lives of Japanese Americans placed in internment camps by the U.S. government. After the war, she continued her life's work of documentary photography, traveling around the country and the world for *Life* magazine.

On the door of her darkroom Dorothea pinned a favorite quote by Francis Bacon. Although she used this quote to inspire and direct her work, it also serves to describe her photography and sum up the way she lived: "The contemplation of things as they are without error or confusion, without substitution or imposture is in itself a nobler thing than a whole harvest of invention."

Bibliography

Blue, Rose, and Corrine J. Naden. *The Progressive Years: 1901 to 1933*. Austin, Tex.: Raintree Steck-Vaughn Publishers, 1998.

Daniel, Pete, Merry A. Foresta, Maren Stange, and Sally Stein. *Official Images: New Deal Photography*. Washington, D.C.: Smithson-ian Institution Press, 1987.

Davis, Keith F. *The Photographs of Dorothea Lange*. Kansas City, Mo.: Hallmark Cards, Inc., 1995.

Hansen, Erica. *The 1920s: A Cultural History of the United States Through the Decades*. San Diego, Calif.: Lucent Books, 1999.

Meltzer, Milton. *Dorothea Lange: A Photographer's Life*. Reprint. Syracuse, N.Y.: Syracuse University Press, 2000.

Partridge, Elizabeth. *Restless Spirit: The Life and Work of Dorothea Lange*. New York: Viking, 1998.

Partridge, Elizabeth, ed. *Dorothea Lange: A Visual Life*. Washington, D.C.: Smithsonian Institution Press, 1994.

Press, Petra. *The 1930s: A Cultural History of the United States Through the Decades*. San Diego, Calif.: Lucent Books, 1999.

Turner, Robyn Montana. *Dorothea Lange*. New York: Little, Brown, 1994.

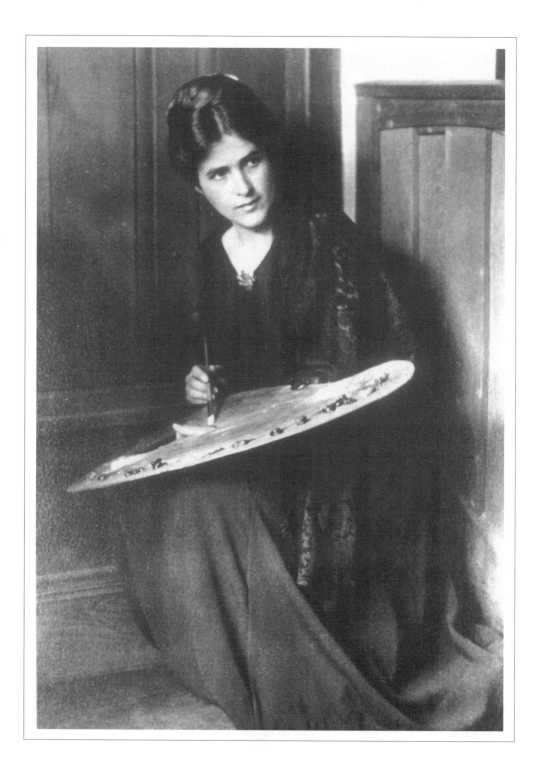

Mary-Russell Colton
(1889–1971)

M ARY-RUSSELL DISCOVERED her life's work in bit and pieces. Raised in Philadelphia, Pennsylvania, she knew she wanted to be an artist from an early age. She pursued her dream with focused energy and drive, not allowing anything, even the sudden death of her father when she was fifteen, to deter her from attending art school.

Upon graduation Mary-Russell set up a small art studio and began selling original oil paintings. The summer after graduation, the city-born and -raised young woman did a brave thing: she traveled west on a two-month backpacking trip into the Canadian mountains. She came home with two new passions; travel and the West.

A few years later, while criss-crossing the country on their honeymoon, Mary-Russell and her husband, Harold Colton, fell in love with Arizona. Where others saw rattlesnakes and cactus, the Coltons saw a home away from home. They returned to Arizona year after year, discovering not only a passion for the landscape, but also a deep connection with the Native Americans living there.

Eventually, the pull of Arizona was so strong that the Coltons uprooted their family and moved to Flagstaff. Explaining her feelings toward the West in a letter to her mother she wrote, ". . . the city and the places that are old with men shall never hold me. I must breathe."

HAROLD: BRITISH COLUMBIA: SUMMER 1911
I first met Mary-Russell as we both set out on a long and arduous trip (her second, my first) into the untamed wilderness of British Columbia. A small party of us, five

OPPOSITE: *Mary-Russell Colton holding her paint palette, 1922. Photograph courtesy of the Museum of Northern Arizona.*

Very Nice to Meet You, Sir

Harold Colton, eight years older than Mary-Russell, was already a zoology professor at the University of Pennsylvania when they met. Because he was the son of a successful banker, money was never an issue for Harold, and thus he was able to pursue a career based on his interests rather than his finances. Harold, known for his quick wit and generous nature, was interested in many areas of science and always enjoyed learning new things. In a letter Mary-Russell wrote to Harold before they were married, she thanked him for awakening her curiosity about the world around her.

men and four women, willingly spent our summer forging raging rivers, camping at the edge of icy mountain lakes, and hiking long days over thickly wooded mountains.

Only five feet, two inches, Mary-Russell quickly earned the nickname Fairy. However, I considered this nickname misleading. In truth, Mary-Russell was as tough as nails. The steeper the trail, the colder the water, the wilder the storm, the more she enjoyed herself. Now, how many women do you know like that? I sure hadn't met any back in Philadelphia.

By the end of that first summer together, I liked every darn thing about Mary-Russell and decided that I didn't want to say goodbye. I set my mind to persuading her to marry me.

Mary-Russell: Philadelphia, Fall 1911

I returned from our trip determined to remain friends with Harold and nothing more. After all, I had my art, my studio, and my career. My life was full enough. Of course, Harold had other plans. He courted me shamelessly, starting off with weekly letters and ending up with daily visits.

Such fun we had. He'd scoot by in his automobile, we called it the Big Blue Choo-Choo, and out we'd go to the opera or theater. Sometimes we'd just stay at home or take a walk.

Harold: May 13, 1911

Finally, I asked Mary-Russell to marry me. Thank goodness she said yes because I'd already planned on a long and happy life together, full of fun, children, art, beauty, and of course, adventures.

Mary-Russell's Mother: May 1912

It certainly was not my idea of fun, the honeymoon those two planned. Sleeping in tents, cooking on campfires, going for days without a bath or even a change of

clothes, for goodness sake! But Mary-Russell couldn't wait to get started. Harold either. Obviously those two made a perfect pair.

MARY-RUSSELL: OUT WEST, SUMMER 1912

Since Harold and I met on a vacation adventure, we thought it only right to begin our married life on an adventure as well. By mid-June we'd already seen Pecos, Taos, and Santa Fe. And I don't mean from the window of a train. Yes, we rode the Santa Fe Railroad to each destination, but it was after the train stopped that the fun began. Harold and I wanted to experience the West firsthand, and for us that meant hiking through it, camping as we went. For me it also meant sketching as I went, lots and lots of sketching. Sometimes I felt like a fever came over me, I sketched so fast and furiously. "Slow down, Fairy," Harold laughed from his place stretched out in the shade of a rock or scruffy juniper tree. "The scenery isn't going anywhere."

But I was. And I wanted desperately to capture the beauty of each place before I left it for another.

TRAIN TOURIST ON WAY TO FLAGSTAFF: SUMMER 1912

When the train stopped in Adamana, Arizona, near the Petrified Forest, a couple scrambled on board. Tramping though the cars in their outdoor clothes, dirty and disheveled, they looked like they needed a good soaping up and scrubbing down. Why, the woman wore a boy's flannel shirt, a skirt that fell to her calves, and lace-up boots. Certainly not proper dress for a lady! "Oh, don't be such an old fuddy-duddy," I said to myself. "After all, this is the Wild West! And I *did* come out here to see the sights." So when that young woman walked by again, I didn't mind her untidiness. In fact, I almost envied it.

SANTA FE RAILROAD

For the most part the Coltons traveled the West on the Santa Fe Railroad. This railroad was established in 1863 and entered an extremely profitable business relationship with Fred Harvey of the Fred Harvey Company. Working together, they provided customers with a total travel experience. Stopping at a Santa Fe Railroad station, passengers could dine at a Fred Harvey Restaurant, known for high-quality food at affordable prices. Some destinations, like the Grand Canyon, provided elegant hotels along with tourist attractions like the Hopi House, where shopping, Indian art demonstrations, and museums exposed travelers to the Native American culture of the area. The Fred Harvey Company also provided transportation and tours to nearby tourist attractions.

Train Conductor: Summer 1912

Hmmph! I didn't like scruffy bums riding on *my* train. I charged those vagabonds extra, figuring that the added expense would turn them right around and off my train.

Mary-Russell: Summer 1912

I couldn't help but smile when that grumpy old conductor asked for an extra sixty cents to ride the train to Flagstaff. Then, I almost laughed out loud when Harold pulled out his wallet, quick as you please, handing over the money with a big smile and a gentlemanly bow.

Harold

Heading straight for the dining car, we noticed the other passengers staring as we sat down at our linen-covered table and put the snowy white napkins on our dusty laps. Mary-Russell leaned over and whispered, "They think we're from around here." And soon enough, our fellow passengers barraged us with questions about what to see and do in the area.

Mary-Russell

Naturally we had plenty to tell them, but what I really wanted to say was, "Get off this train and see for yourself. It's a lot more fun!" Harold must have read my mind. He flashed me a smile that would melt an iceberg, and with his grimy face, well-worn plaid shirt, and scuffed boots, he melted my heart as well. Not even two months married and I couldn't be happier.

Mary-Russell's Mother: Philadelphia, Summer 1912

I just loved getting letters about their trip. Those two kids were having so much fun. And amongst all that bouncing around from place to place, Mary-Russell always managed to find time to sketch and paint. After she finished a number of pictures, she'd bundle them up and send them home to me for safekeeping. Of course, I loved looking at pictures of all the places they'd been. When Mary-Russell came home, she used the ideas and the scenes from those sketches to make bigger oil paintings.

I Found It

As the Coltons returned time and again to Flagstaff, they explored the area and eventually stumbled on undiscovered ancient Indian ruins. One such discovery occurred near the place they camped on their first visit and is now known as Elden Pueblo. Mary-Russell described what happened in a letter to Harold in October 1916. "Crossing the lumber railroad I soon came out on a very high mound and suddenly realized I had found the largest Pueblo we have yet come upon. I should say it had been quite equal in size to Walpi, the buildings at the northern end having been at least 2 stories and I believe 3 stories, the entire mound is over 15 feet high. . . . Tomorrow I return to take measurements and make a sketch."

MARY-RUSSELL: FLAGSTAFF

Our train pulled into Flagstaff, Arizona, about 11:00 P.M. Harold and I found a nice clean hotel room. I sank into a sound sleep almost as fast as I sank into that soft bed. And the next morning I absolutely reveled in the luxury of a long soak in a hot bath, the first one I'd had in days . . . or was it weeks?

KATE: FLAGSTAFF, SUMMER 1912

My husband, Ben, and I are old friends of the Coltons. We hooked up with them near Flagstaff. Mary-Russell and Harold brought out a new load of food and supplies when they joined us on Elden Mesa. They admired our very elegant camp, but the credit belonged to Mother Nature, who truly seems to be at her decorating best in Arizona. We marveled that the dry heat of the Painted

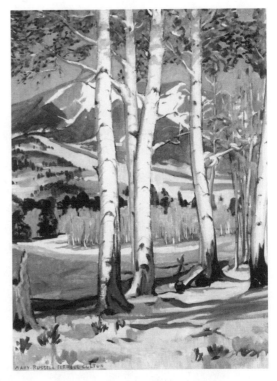

Painting by Mary-Russell Colton, "Hart Prairie," oil, 30 x 24 inches, 1930. Collection of the Museum of Northern Arizona.

Desert was so close to this cool mountain paradise near the San Francisco Peaks. After visiting awhile, Harold said, "Well, Fairy, we've scrambled over mesas, and hiked through dry deserts. I think it's time we climb a mountain. Don't you agree?" The rest of the day we pored over a map and discussed exactly where and which mountain to climb.

THREE REGIONS

A traveler in Arizona once noted, "If ya don't like what you see, keep on driving. In ten minutes it'll be totally different." Arizona has three distinct land regions. The Colorado Plateau, in the northern part of the state, is made up of high plateaus, flat-topped mesas, and hardwood forests. Flagstaff is on the edge of the Colorado Plateau. The middle part of the state is called the mountain zone and consists mainly of mountains and forests. Finally, the desert region covers the southern part of the state and includes the large cities of Phoenix and Tucson.

MARY-RUSSELL

Two days of hard hiking brought us into the shadow of the summit. We pulled our coats tighter, because even though the sun shone brightly and our calendar said June, the air felt downright wintry. Once we stopped for the night, the gathering of firewood became our first priority. We worked quickly to set up camp. I found a big rock and pounded in the tent stakes. Harold started the fire and I arranged our gear inside of the tent. Soon, our comfy camp felt like home, right down to dinner bubbling over the crackling fire.

HAROLD

We woke up at four the next morning. Yes, that's right, I said four o'clock! Leaving the warm cocoon of my blanket to step out into the frozen darkness was no easy task. Luckily, the fire embers still glowed and with a little bit of work and a lot of patience the flames flared up once again. Soon, a pot of melted snow sizzled and steamed above it. Warm drinks in hand, we prepared our assault on the peak. Navigating in the dark, on tree-bare, rocky slopes, our tired feet carried us up the mountain.

MARY-RUSSELL

Actually, as we hiked the sun climbed out of its nighttime bed and together we reached the summit of Mt. Fremont.

A world of beauty lay at our feet. "I give you your kingdom, my lady," Harold joked as he bowed before me. Looking out over the land that we had traveled and knew well, I smiled.

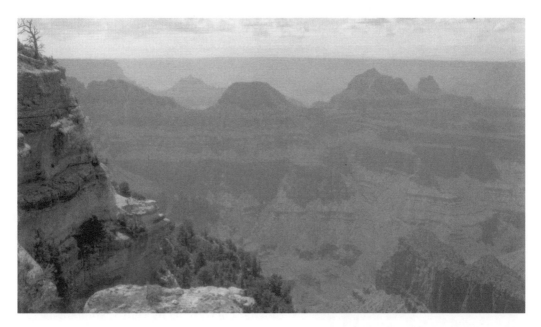

View of Grand Canyon National Park, Arizona. Photograph courtesy of the Denver Public Library Western History Collection.

HAROLD: SUMMER 1912

We took the train to the Grand Canyon, planning on a nice long stay of five days. It was strange to be around so many people again. We had been off by ourselves in the wilderness for so long, the Grand Canyon seemed positively civilized.

BEN: GRAND CANYON

Civilized? Ha! I'm sure our friends from Philadelphia would disagree. Real live cowboys sauntered around in dusty chaps and silver-spurred boots, their eyes half hidden by wide-brimmed hats. An Indian in moccasins sat patiently for tourist pictures, his long narrow braids neatly wrapped in leather. Mules snorted and brayed as they waited to carry white-

A BACKWARD HIKE

A hike down into the canyon is a walk into the past. In his book Arizona: A Cavalcade of History, *Marshall Trimble describes the canyon this way: "The Grand Canyon presents geologists with a layer-to-layer record, a vertical mile of planetary history. In the inner gorge . . . lie some of the oldest rocks known to man. In the canyon one can see sandstone formed from ancient desert sand dunes. Deep in the gorge are the remains of mountain ranges that reigned majestically over this land more than two billion years ago."*

knuckled tourists below the rim. We saw fancy-dressed ladies picking their way through the dirt and rocks to peek timidly over the rim. "They look as out of place as a chile pepper in an English flower garden," Mary-Russell laughed.

MARY ELIZABETH COLTER

Although architectural design and decoration was an unusual career for women in the early 1900s, Mary Elizabeth Colter made it her life's work. In fact, she was the brains behind the beauty of the Hopi House. Working for the Fred Harvey Company, Colter eventually designed and supervised the construction of five structures in Grand Canyon National Park. Hopi House was her first Grand Canyon assignment. She modeled it after a pueblo home she visited in Oraibi on Third Mesa, hiring Hopi Indians to build it with an authentic look and feel.

MARY-RUSSELL: GRAND CANYON

I practically kicked Harold out of our tent, I was so anxious to get started with my painting. While he hiked the Bright Angel Trail down to the Colorado River, I wandered around until I found a solitary perch looking out over the widest part of the canyon. Beside me a twisted juniper tree held on to the rocky rim with gnarled roots, and far below me the river slithered along the canyon floor and then disappeared behind a curve. Can anyone see this sight and *not* be moved? I wondered.

HAROLD

"Wait till you see this!" Mary-Russell said, grabbing my hand as I returned from my hike. She led me—pulled me, to tell the truth—to a building that looked like an ancient Indian pueblo. "This," she said with a flourish, "is the Hopi House. I just know you'll love it!" And she was exactly right.

Inside, Hopi and Navajo Indians worked at their crafts of weaving, pottery making, and silversmithing. After we watched them work, we shopped, buying two old blankets and a woven basket.

That night we attended the Indian dances held in front of Hopi House. The Hopi men danced and sang while the sun set, drenching the layered canyon wall in purples and violets.

MARY-RUSSELL

One afternoon I sketched the storm clouds as they stacked up on one another. Rumbling thunder rolled over the canyon, bouncing back and forth off the walls. *Splat*, a heavy drop of rain landed on the dirt beside my foot. *Splat*, another fell. And

then another and another. I hurried to finish off my sketch, and even though the raindrops came more quickly, I couldn't tear myself away from the towering strength of that thunderstorm.

When I finally ran for cover to our tent, the wind snapped the canvas and the sweet smell of rain and damp earth tickled my nose.

HAROLD: SUMMER 1912

We reluctantly left the Grand Canyon. We had so much more to see and do on our summer trip before my teaching duties and Mary-Russell's painting called us back to Philadelphia in the fall.

MARY-RUSSELL: PHILADELPHIA, EARLY SPRING 1913

By spring we were all moved into Singing Wood, our brand-new home. Although I loved managing the house and adored my large and airy new studio, I often found myself thinking back to our honeymoon adventure. Day-dreaming about a schedule that changed with the day and our mood. I missed the excitement of waking up in one place and going to sleep somewhere else. And I missed the freedom of a lifestyle guided only by our interests, not by our responsibilities.

HAROLD: EARLY SPRING 1913

One evening after work, I attended a lecture and slide show on the Hopi and Navajo Indians of Arizona. I found it absolutely fascinating, especially since Mary-Russell and I had traveled briefly through Hopi and Navajo country on our honeymoon. I wanted to go back and see more. "How about another trip out West?" I asked Mary-Russell the next night over dinner. The smile on her face said it all.

WILD WEATHER WOMAN

Although Mary-Russell loved the great outdoors at all times, she especially liked rough weather and wild storms. Sharing her feelings in a letter to her mother, she wrote, "These great moods of nature move my very soul, and though I love her when she smiles, it is the wild dark mood, the shrieking wind and flying snow that seem to lift me up and bear me on with the storm on the wings of freedom."

MARY-RUSSELL: SUMMER 1913

The whistle blew and the train lurched and lugged slowly forward. My heart positively sang as we left the station, heading west. We had worked and planned and dreamed about our trip through the long wet days of spring. "We are on our way,"

To Sign or Not?

Mary-Russell continued with her career as a professional artist even after her marriage. She had a large art studio in her home where she painted and did restoration work. It is interesting to note that from the late 1800s to mid-1900s, many women artists were discriminated against purely because of their gender. To keep this discrimination from affecting sales many women artists hid their gender by signing their art with their initials. Mary-Russell signed her pictures with her full name.

I said to Harold with a sigh of pure pleasure. He squeezed my hand in reply.

Mary-Russell: Summer 1913

We traveled by horse and buggy to Ganado, Arizona, the home of John Lorenzo Hubbell, and the Hubbell Trading Post. Mr. Hubbell allowed us to camp near his home, and each morning he ambled over to join us for a breakfast of griddle cakes and camp coffee. A gracious gentleman of medium height, his mustached face leathered and lined with years of squinting into the sun, he generously shared with us his vast knowledge of Indian arts, crafts, and customs. We listened, entranced by his stories, always full of questions and eager to learn more.

Harold

Our wagon, driven by an Indian guide, bounced and shook its way to Hopi country on

John Lorenzo Hubbell

Born in Pajarito, New Mexico, to a bilingual and bicultural family, John Lorenzo Hubbell grew up communicating with different cultures. He used this ability to his advantage when he came to Ganado, Arizona, in 1876 and began trading with the Navajo Indians. Hubbell was known for his respectful interactions with the Natives and for his charm and generous hospitality. He entertained often and well in his large hacienda-style home. In fact, while the Coltons camped in Ganado, Hubbell's houseguests included former President Theodore Roosevelt and Arizona Governor George W. P. Hunt. The Hubbell Trading Post in Ganado, Arizona, is now preserved as a National Historic Monument. If you visit, you can walk through the still-functioning trading post. You can also tour Hubbell's family home.

a barely visible wagon track. It took us two days to reach Polacca, Arizona, a small town snuggled at the base of the Hopi First Mesa. The land here is basically flat with the occasional mesa rising straight up from the valley floor, looking more like a rough granite castle than anything else.

At first the land seemed dry and lifeless. We saw no houses or even people. But as my eyes got accustomed to the landscape, I noticed little fields of green tucked into the shadows of the mesa or in a washed-out gully.

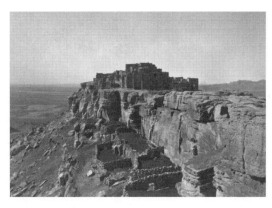

The Pueblo village, Walpi, teeters on the edge of First Mesa, 1912. Photograph courtesy of the Denver Public Library Western History Collection.

MARY-RUSSELL

I looked to the mesa top with much anticipation. "There is no pueblo up there," I said, disappointed. The wagon driver smiled and said, "Look again." I scanned the mesa top back and forth, back and forth. And then, a flash of light, perhaps the sun glinting off a silver buckle, drew my eye to the pueblo of Walpi. "I see it. I see it," I called, pointing out the location to Harold.

In Polacca, a man named Tom Pavatea greeted us warmly. Tom ran the trading post there, and he rented us a little stone house that we used as our base to visit the Hopi villages nearby.

HAROLD

We followed the ancient gravel footpath from Polacca to the First Mesa, climbing our way up a rock-strewn path, and on the way passing farmers heading down to attend their crops.

WEST IS BEST FOR WOMEN

At the turn of the century, western women enjoyed more freedom than their eastern sisters did. Maybe that's why Mary-Russell enjoyed her trips west. Women had voting privileges in most western states by 1915, and Arizona women voted in 1912, even though the Nineteenth Amendment giving women the right to vote didn't pass until 1920. By 1924, the West had elected the first woman to the U.S. Congress. Texas and Wyoming had women governors and the city of Seattle had elected a woman as mayor.

We also passed groups of women laughing and chattering, their water jars balanced on their heads.

Mary-Russell
Burros milled around in the dirt street while laughing children chased chickens back and forth. Ladders made from round peeled tree trunks leaned against rough stucco walls, and strings of red chiles hung by every door. I stopped to make some sketches, trying to capture every detail. Soon a small crowd had gathered around me, laughing and pointing as they recognized their village on my sketching pad.

Mary-Russell
Peering over the edge of the mesa, we saw the valley stretched out below us. The bleats and baas of a herd of sheep wafted up from the valley floor, and flat-bottomed clouds floated by, dragging their shadows across the shimmering valley.

Harold
Our trip continued to other parts of the West. We saw many beautiful things, but Mary-Russell and I both knew that although our bodies may travel far, a piece of our hearts will always remain in Arizona.

Mary-Russell
When we returned to Philadelphia, I started working right away, eager to finish some paintings for my annual Philadelphia Ten exhibit. My very spirit was filled up with the stark and ancient beauty of all I had seen.

I also organized an exhibition to show the many beautiful Hopi crafts we purchased on our trip. All those who saw them were astonished at their simple and powerful beauty. I wished there was a way I could help the Hopis continue making their art forever.

❦ *Afterword* ❦

MARY-RUSSELL AND Harold did in fact leave a piece of their hearts in Arizona. Over the next thirteen years they returned to Flagstaff and the surrounding area many times. Eventually, in 1926 they moved there to stay.

In 1928, the Coltons helped found the Museum of Northern Arizona. Mary-Russell was appointed the art curator, a job she took seriously for the rest of her life. Determined to bring art to northern Arizona, she developed programs that offered art education to local residents as well as access to quality art through regular exhibitions at the museum. She worked tirelessly to revitalize Hopi and Navajo traditional crafts by providing a market where Indian craftspeople could display and sell their work.

In addition to her full-time commitment to the museum, Mary-Russell continued to paint her western landscapes and portraits of Native Americans.

As a young girl, Mary-Russell Colton said, she wanted two things out of life: to be an artist and to travel to faraway places. Because of her hard work, determination, and willingness to live life to the fullest, Mary-Russell's real life far exceeded her girlhood dreams.

MESA TOP HOMES

The Hopi Indians didn't always live on the mesa tops. They fled there for protection when the more warlike Utes, Apaches, and Navajo began moving into the area.

PHILADELPHIA TEN

In January 1917, Mary-Russell and some of her artist friends from school organized themselves into a group called "The Ten." These serious and gifted women artists wanted a chance to exhibit, and thus sell, their work "in the most dignified and harmonious manner." They held annual exhibitions at various locations in Philadelphia, starting in February 1917. Mary-Russell continued to exhibit her work as part of The Ten through 1940.

The Rest of the Story

Mary-Russell and Harold did not remain footloose and fancy-free forever. Their first son, Joseph Ferrell Colton, was born in 1914, and their second son, Sabin Woolworth Colton IV, was born in 1917. Having children didn't slow the Coltons down, however. They continued to spend their summers traveling, but after the children were born they brought the nanny along with them.

Sadly, Sabin died in 1924. During a winter visit to Tucson, he contracted valley fever, an illness caused by exposure to a fungus that grows in desert soils.

~ Bibliography ~

Howard, Kathleen L., and Diana F. Pardue. *Inventing the Southwest: The Fred Harvey Company and Native American Art.* Flagstaff, Ariz.: Northland Publishing, 1996.

Kovinick, Phil, and Marian Yoshiki-Kovinick. *An Encyclopedia of Women Artists of the American West.* Austin: University of Texas Press, 1998.

Mangum, Richard K., and Sherry G. Mangum. *One Woman's West: The Life of Mary-Russell Ferrell Colton.* Flagstaff, Ariz.: Northland Publishing, 1997.

Miller, Jimmy H. *The Life of Harold Sellers Colton.* Tsaile, Ariz.: Navajo Community College Press, 1991.

Sneve, Virginia Driving Hawk. *The Hopis.* New York: Holiday House, 1995.

Trenton, Patricia, ed. *Independent Spirits: Women Painters of the American West, 1890–1945.* Berkeley: Autry Museum of Western Heritage in association with the University of California Press, 1995.

Trimble, Marshall. *Arizona: A Cavalcade of History.* Tucson, Ariz.: Treasure Chest Publications, 1989.

Index

(Note: Page numbers in italics indicate photographs and paintings.)